African-American Artists, 1929–1945

African-American Artists, 1929–1945

Prints, Drawings, and Paintings in
The Metropolitan Museum of Art

LISA MINTZ MESSINGER LISA GAIL COLLINS

RACHEL MUSTALISH

THE METROPOLITAN MUSEUM OF ART

YALE UNIVERSITY PRESS

This catalogue is published in conjunction with the exhibition "African-American Artists, 1929–1945: Prints, Drawings, and Paintings in The Metropolitan Museum of Art," held at The Metropolitan Museum of Art, New York, January 15–May 4, 2003.

The exhibition is made possible by The Fletcher Foundation and Fletcher Asset Management, Inc.

Additional support has been provided by Jane and Robert Carroll.

Published by The Metropolitan Museum of Art, New York
John P. O'Neill, Editor in Chief
Emily Walter, Editor
Robert Weisberg, Designer
Peter Antony, Production
Jean Wagner, Bibliographic Editor

Photography of works in the catalogue by Mark Morosse, The Photograph Studio, The Metropolitan Museum of Art

Typeset in Bauer Bodoni
Color separations by Professional Graphics, Inc., Rockford, Illinois
Printed on R-400 150 gms by Brizzolis Arte en Gráficas, Madrid
Bound by Encuadernación Ramos, S.A., Madrid
Printing and binding coordinated by Ediciones El Viso, S.A., Madrid

Library of Congress Cataloging-in-Publication Data

Metropolitan Museum of Art (New York, N.Y.)
 African-American artists, 1929–1945: prints, drawings, and paintings in the Metropolitan Museum of Art / Lisa Mintz Messinger, Lisa Gail Collins, Rachel Mustalish.
 p. cm.
 Catalog of an exhibition held at the Metropolitan Museum of Art, New York, Jan. 15–May 4, 2003.
 ISBN 1-58839-035-7 (pbk.) — ISBN 0-300-09877-4 (Yale University Press)
 1. African American art — 20th century — Themes, motives — Exhibitions. 2. Art — New York (State) — New York — Exhibitions. 3. Metropolitan Museum of Art (New York, N.Y.) — Exhibitions. I. Messinger, Lisa Mintz. II. Collins, Lisa Gail. III. Mustalish, Rachel. IV. Title.

N6538.N5 M47 2003
704.03'96073'00747471—dc21
2002041056

Cover illustration: Jacob Lawrence (1917–2000), *The Photographer*, 1942. Detail of catalogue no. 18

Contents

Sponsor's Statement

The Fletcher Foundation and Fletcher Asset Management, Inc., are proud to sponsor The Metropolitan Museum of Art's exhibition "African-American Artists, 1929–1945: Prints, Drawings, and Paintings in The Metropolitan Museum of Art." This exhibition, the first at the Metropolitan Museum in recent years to highlight the accomplishments of twentieth-century African-American artists, features more than eighty works that address aspects of daily life for African Americans during the latter part of the Harlem Renaissance, the Great Depression, and World War II.

With an uncompromising commitment to making investments that create value for all participating parties, Fletcher Asset Management, Inc., as the investment advisor for several investment funds, has provided capital to sustainable businesses for more than a decade. Focusing on the objectives of philanthropic families and organizations, the funds Fletcher Asset Management, Inc., advises span a variety of investment ventures, with features tailored to individual U.S. investors, tax-exempt U.S. organizations, and international individuals and organizations.

Fletcher is committed to creating value not only for its investors and the companies in which it invests but also for the population at large. The pursuit of this goal is the mission of The Fletcher Foundation. It is because the artists in this exhibition have contributed so meaningfully to the enjoyment and aesthetic stimulation of all those who have seen their work that Fletcher is privileged to help make it more accessible to a broader audience.

In addition to supporting educational advancement and preserving and developing communities in a sustainable manner, The Fletcher Foundation appreciates the value inherent in supporting the arts, especially those programs and artistic expressions that promote diversity and tolerance. Fletcher Asset Management, Inc., and The Fletcher Foundation are therefore delighted to join The Metropolitan Museum of Art in focusing attention on the invaluable contribution that the artists in this exhibition have made to the canon of twentieth-century American art.

Dr. Bettye R. Fletcher
Director
The Fletcher Foundation

Alphonse Fletcher, Jr.
Chairman
Fletcher Asset Management, Inc.

Director's Foreword

The exhibition "African-American Artists, 1929–1945: Prints, Drawings, and Paintings in The Metropolitan Museum of Art" and this publication have been organized to showcase the Museum's expanding collection of African-American art. The collection was initiated with the purchase in 1942 of two modern works, Jacob Lawrence's *Pool Parlor* and Richmond Barthé's sculpture *Boxer*, and the pace of acquisitions has greatly accelerated over the past sixty years. The collection now totals some five hundred works in a variety of media—paintings, sculptures, prints, photographs, and textiles. It spans the nineteenth century to the present, and it involves five curatorial departments.

The current selection is inspired by the gift in 1999 from Reba and Dave Williams of 204 prints by African-American artists. Noted for their extensive collection of American prints from 1900 to 1950, both by recognized masters and by lesser-known artists, the Williamses have focused especially on the work of African-American printmakers. Their passionate pursuit of this material has led to the resurrection of many lost works and careers, and to a reevaluation of the contributions made by African Americans to the history of American art.

The Metropolitan Museum here acknowledges these contributions specifically during the years 1929–1945, in terms of new subject matter and technical advances.

The images reflect the social and economic times of World War II and the Great Depression, particularly for African Americans, and they also speak poignantly of the human dramas, large and small, that inflect all our daily lives.

The exhibition and publication are the result of the dedicated work of Lisa Mintz Messinger, Associate Curator in the Department of Modern Art, in consultation with the department's Chairman, William S. Lieberman. Their sensitive selection and arrangement of the material contribute to our understanding and appreciation of these works. For her part as author of the individual catalogue entries Lisa Gail Collins, Assistant Professor in Art History and Africana Studies at Vassar College, must be warmly thanked, as must Rachel Mustalish, Associate Conservator at the Metropolitan Museum, who wrote the catalogue's informative essay on printmaking techniques during the WPA.

The Museum extends its sincere gratitude to The Fletcher Foundation and Fletcher Asset Management, Inc., for their generous support of the exhibition. We are also indebted to Jane and Robert Carroll for their kind assistance toward this project.

Lastly, we salute the foresight and generosity of Reba and Dave Williams, who amassed the unique collection of prints that now forms the cornerstone of our own African-American holdings.

Philippe de Montebello
Director
The Metropolitan Museum of Art

Acknowledgments

Exhibitions and publications are the result of the collaboration of many people, and this project is no exception. First and foremost, I must acknowledge William S. Lieberman, Jacques and Natasha Gelman Chairman of the Metropolitan Museum's Department of Modern Art, who helped shape the contents and format of this presentation. He, together with Lowery S. Sims, former Curator in the department and now Director of the Studio Museum in Harlem, were instrumental in acquiring the Reba and Dave Williams collection for the Museum and in building the Museum's holdings of African-American art.

Special appreciation is extended to Professor Lisa Gail Collins, who brought her knowledge of art history and African-American studies to the task of writing entries for the catalogue in a few short months during her sabbatical from Vassar College. Many thanks also to Rachel Mustalish, Associate Conservator at the Metropolitan Museum's Sherman Fairchild Center for Works on Paper and Photograph Conservation, who conserved all the prints and drawings for the exhibition, with the assistance of Ann Baldwin, Valerie Faivre, and Yana Van Dyke, and wrote the essay on printmaking for this publication. As always, her insights into the ways artists create their images have enriched my own understanding of our collection.

Senior editor Emily Walter put in many long hours perfecting the publication, and her diligent efforts are duly reflected in the final product. Her good humor and enthusiasm for the material made our collaboration a pleasure. Also in the Editorial Department, Chief Production Manager Peter Antony and designer Robert Weisberg, under the direction of John P. O'Neill, Editor in Chief, brought this catalogue to fruition.

Two student assistants in the Department of Modern Art, Sarah Newman, a graduate fellow, and Imo Nse Imeh, a six-month postcollege intern, deserve special commendation for their months of hard work on various phases of the catalogue and exhibition preparation. My sincere thanks go to my co-workers in the department—those who lent their moral support, and those who contributed directly to the project: Kay Bearman, Ida Balboul, Shirley Levy, Sarah Bergh, Megan Heuer, Faith Pleasanton, Tony Askin, Dennis Kaiser, and especially Cynthia Iavarone, who kept all the balls in the air with aplomb. For her good counsel, I am grateful to Donna Sutton, Audience Development Specialist in the Museum's Membership Department.

Lastly, to all the other people at the Museum who contributed to "African-American Artists, 1929–1945," from many different departments—Antenna Guide, Communications, Design, Development, Director's Office, Drawings and Prints, Education, Facilities Management, Membership, Merchandise, Paper Conservation, Paintings Conservation, Photograph and Slide Library, The Photograph Studio, Visitor Services, and the Web Group — Thank You. The project could not have been done without you.

Lisa Mintz Messinger
Associate Curator
Department of Modern Art

African-American Artists, 1929–1945

Introduction

LISA MINTZ MESSINGER

This publication and the accompanying exhibition, "African-American Artists, 1929–1945: Prints, Drawings, and Paintings in The Metropolitan Museum of Art," focus on a very specific period—the years 1929 to 1945—one in which catastrophic economic and political events ironically led to a revitalization of the arts in America. Most notably, art made by African-American artists flourished at this time in unprecedented ways, deriving benefits from what the art historian Lisa Gail Collins has enumerated as "access to quality materials, public commissions, training, living wages, professional colleagues, exhibition opportunities, etc."[1] In large part, the positive outlook for American artists was the result of an increased awareness of and support for the arts across a broad spectrum of society, one that traversed racial, social, and economic lines. The graphic arts in particular—that is, fine art prints, posters, and illustrations for books, magazines, and newspapers, all of which had the potential of disseminating ideas to a mass audience—were elevated to a medium of importance in American art. Before then, as the art historian Lowery Stokes Sims has observed, "prints tended to be viewed even by the artists as experimental activities or temporary diversions, certainly not 'serious' endeavors as painting or sculpture."[2] The current selection of works by African-American artists from the collection of The Metropolitan Museum of Art specifically addresses the primacy of printmaking during this era, drawing extensively from the more than two hundred prints donated to the Museum in 1999 by Reba and Dave Williams. With this single gift (which will be discussed in greater depth

later in this introduction), the Metropolitan's holdings in the field of African-American art have taken a giant leap forward.

The African-American involvement in print-making has been described by the art historian Leslie King-Hammond:

> During the first three decades of the twentieth century, blacks who followed this profession found outlets for their work in magazines, newspapers, journals, and other popular publications. Access for black artists was primarily limited to the pages of publications that focused on issues of race relations and their sociopolitical ramifications. Magazines such as [The] Crisis, Survey Graphic, and Opportunity afforded these artists the greatest amount of exposure. It was not until the years of the WPA [Works Progress/Work Projects Administration, the federally sponsored art programs that provided jobs for the unemployed] that black artists found viable conditions to explore their own creativity, develop printmaking processes and gain access to new technologies.[3]

During the 1930s and 1940s, African-American artists were drawn to working on paper for prints, drawings, collages, and paintings, for both economic necessity and philosophical belief. Not only were they inexpensive to make, they were inexpensive to buy and could be purchased by a broad socioeconomic population. Accordingly, as interest in the graphic arts grew, African Americans were increasingly recognized for their contribution to this field.

The time frame of this study is bracketed by two significant dates in the nation's history: 1929, the year of the stock market crash and the onset of the Great Depression, and 1945,

which marked the end of World War II. Also of specific relevance to this discussion, 1929 signaled the end of the Harlem Renaissance, a golden decade of political strides and major literary and musical achievements by African Americans. It was a time when, in the words of the theater critic Brendan Gill, "black writers, artists, composers, and theater performers were thought to be opening the door to a promising future—one that could be shared with a white majority only just beginning to perceive black culture not as a form of failed white culture but as something that had its own complex nature."[4] The provocative essay by the philosopher Alain LeRoy Locke (1886–1954), "The Legacy of Ancestral Arts," which appeared in the anthology *The New Negro*, published in 1925, laid the groundwork for the next generation's interpretations of artistic heritage, affirming not only the legitimacy but the necessity of understanding Africa and African art as sources of inspiration for contemporary African-American culture. If blacks were to create an authentic art that was their own, it could not be based solely on European modernism but had to acknowledge their own heritage.

Despite being fraught with social injustices directed specifically toward African Americans (including racism, job discrimination, and lynchings—more than one hundred such murders took place during this time) and severe economic hardship (by 1933, 15 million Americans were unemployed), the period 1929–1945 was, unexpectedly, ripe with idealistic hopes and tangible opportunities for all artists in America. As the art historian Barbara Rose has written, the 1930s emerge as "the crucial years . . . the decisive decade for American art, if not for American culture in general."[5]

Of particular importance was the implementation, under President Franklin D. Roosevelt's New Deal (1933–43), of various government-sponsored arts programs. (Serendipitously, the Museum's exhibition and this accompanying publication in 2003 coincide with the seventieth anniversary of the first New Deal program.) Although active for only six and a half months, the short-lived Public Works of Art Project (PWAP) employed some 3,700 artists and handled 15,000 works of art. This program was soon followed by the Treasury Department's Section of Painting and Sculpture (later called the Section of Fine Arts) and the enormously successful WPA (Works Progress Administration, renamed the Work Projects Administration in 1939), by which the majority of artists were employed. (The WPA also funded programs in music, theater, and literature.) In total, some 3,500 to 5,000 artists participated in the WPA's Federal Art Project (WPA/FAP) from 1935 to 1943, each receiving an average weekly paycheck of about twenty-three dollars.[6] They worked in more than one hundred art centers across the country and produced approximately 2,500 murals for public buildings; 108,000 oil paintings, drawings, and watercolors; 17,000 sculptures; 200,000 prints from over 11,000 original designs; and 2 million silk-screen posters from 35,000 designs.[7] Although it is not possible to state the total number of African-American artists working for the WPA/FAP in the various divisions, Reba and Dave Williams (prominent collectors of WPA prints) have accounted for "seventeen African-American 'WPA printmakers' [who] can be identified with certainty. However, some of these artists made WPA prints while serving as instructors, or while students, at WPA-sponsored art schools . . . they were not employed by the WPA to make prints."[8]

It must be noted, however, that compared with white artists, African Americans were significantly underrepresented in the WPA in relation to their total numbers in the general population. These were highest in cities like New York, Chicago, Philadelphia, Atlanta, and Cleveland, where major art centers flourished. Places like the Harlem Community Art Center (New York City), for example, and the South Side Community Art Center (Chicago), the Federal Art Projects Graphic Arts Division

Workshop (Philadelphia), and Playhouse Settlement/Karamu House (Cleveland) played a key role in advancing the development of African-American artists.

The federal art programs were not only intended to provide "work-relief" to unemployed artists but also to "effect [a] cultural revolution by integrating art into the daily lives of the American public."[9] Operating under this mission,

> [artists were afforded] the opportunity—which most had never had—to [create art] full time; the WPA gave them a sense of professionalism previously unavailable outside the academic context. By giving artists materials and time, it allowed them to develop their skills and technique to a new level. Throwing artists together in communal enterprises, the WPA experience provided an *esprit de corps* that carried over into the forties. Not the least of its contributions was the sponsorship of exhibitions and classes which served to arouse a consciousness of art in the far reaches of the country.[10]

Under this government sponsorship, African Americans gained unparalleled access to art resources and found a generally welcoming community of artists to collaborate with and learn from, as well as a talented group of students to instruct. Artists from different backgrounds worked side by side for the same cause. Since then, many former WPA artists have expressed the opinion that "the WPA years had been a special time—a time of freedom of expression and freedom of style, without discrimination or censorship."[11] In 1990, the artist Hughie Lee-Smith (see cat. no. 33) said: "We artists got along . . . as human beings creating art. There were no black projects or white projects. There were WPA Federal Art Projects."[12]

But not all experiences were so positive, and racism in American society sometimes carried over into hiring practices for government projects.

> Agencies such as the WPA . . . created hiring guidelines to ensure that black employees comprised only a certain proportion of the staff. Additionally, the WPA typically paid black employees less than white employees, because 'African Americans were considered to be accustomed to lower wages.' Regardless of their skill or educational level, blacks were typically classified as unskilled and their applications were handled more slowly. Although legislation was eventually passed to protect against discrimination in the WPA, local racist agency officials continued to evade the rules, making employment difficult.[13]

Protests about the system were expressed in the African-American press and in songs like "WPA Blues" (1936), recorded by the blues musician William "Casey Bill" Weldon.[14]

Although the government employed both abstract and representational artists, most of the work produced for these programs followed the American Scene style of realism and narrative imagery, which was popular with the public and dominated the art of the 1920s and 1930s. There was a recognition that the government was supporting American art *by* Americans *for* Americans, and images that reflected the times—agricultural workers, industrial laborers, and the indigent—proliferated. Ironically, while most artists viewed participation in the WPA and the art produced for it as progressive gestures, these same subjects were later derided when they became equated with leftist politics. The work of such painters as Thomas Hart Benton (1889–1975; fig. 1), John Steuart Curry (1897–1946), and Grant Wood (1892–1942) epitomized the American Scene's Regionalist aesthetic that imbued glorified images of America's Midwestern farms with patriotic idealism. Other American Scene painters, such as Ben Shahn (1898–1969), Moses and Raphael Soyer (1899–1974; 1899–1987), and Reginald Marsh (1898–1954; fig. 2), were known as Social Realists and worked in urban settings that chronicled the courage and desperation of people living through the Depression. Underlying much of this work was an avowed belief in the

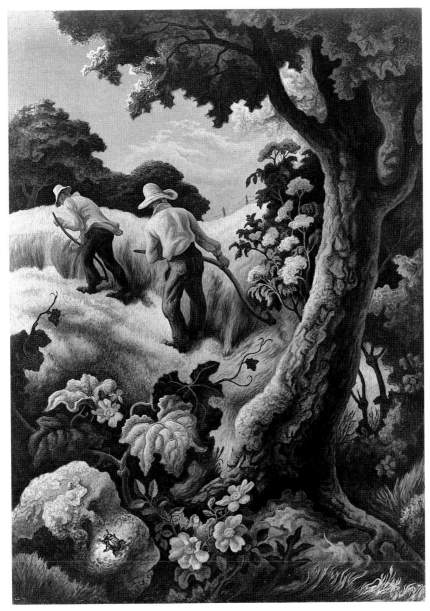

Figure 1. Thomas Hart Benton (1889–1975), *July Hay*, 1943. Egg tempera, methyl cellulose, and oil on Masonite, 38 x 26¾ in. (96.5 x 67.9 cm). The Metropolitan Museum of Art, George A. Hearn Fund, 1943 (43.159.1)

strength and endurance of the American people, even in the face of adversity.

For artists working in the New Deal programs, realistically rendered narratives and scenes of daily life were the expected forms of expression, but, in fact, the administrative agencies placed few restrictions of any kind on an artist's style, subject matter, or choice of medium. This freedom led many to explore new techniques, especially in the printmaking studios, where several revolutionary advances were made. Dox Thrash's invention of the carborundum print (see cat. nos. 28, 43) and the refinement of color lithography and silk-screening are notable examples. (A more in-depth discussion of WPA prints may be found in the essay by Rachel Mustalish in this catalogue, pp. 83–90). For African-American artists, the freedom to choose images of personal significance meant that they could record the dignity of people from their own communities going

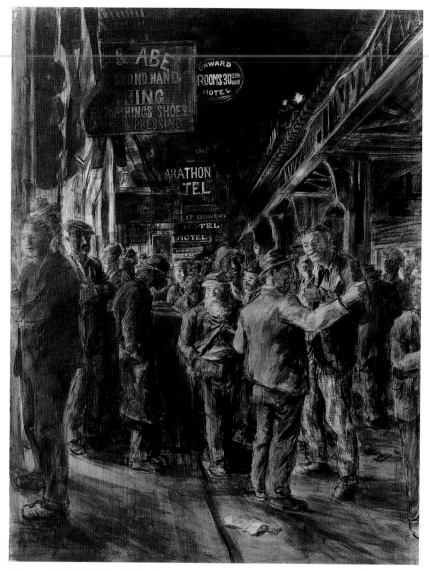

Figure 2. Reginald Marsh (1898–1954), *The Bowery*, 1930. Tempera on Masonite, 48 x 36 in. (121.9 x 91.4 cm). The Metropolitan Museum of Art, Arthur Hoppock Hearn Fund, 1932 (32.81.2)

about their daily lives, with family, at work, and in the religious community, against the backdrop of the Depression and the social inequities of racial discrimination. Occasionally, such issues are confronted overtly —as in Ernest Crichlow's *Lovers* (cat. no. 15), a jarring scene of rape and bigotry—but more often they are covertly conveyed through coded references that are evident only to those who are sensitized to their meaning. As an example, we might almost overlook the tiny noose hanging from

the tree in the background of Charles Wilbert White's *Hope for the Future* (cat. no. 5), but once noticed, it adds a jolting reminder of the lynchings taking place in the South at that time, making a poignant scene of a mother and child even more powerful.

For many African-American artists, even those working in northern cities, images of the rural South held particular cultural and historical significance. Painful associations with slavery, the Civil War, segregation, and the massive

migration of families from the South to the North were all connected with the South, as were more pleasant memories of an agrarian lifestyle, outdoor barbecues, jazz and blues, and close-knit communities. While the Regionalist painters expressed feelings of patriotism in their Midwestern farm scenes, the depictions of southern life by African Americans were more personal and complex, imparting layers of meaning beyond the mere recording of narrative details.

The government's sponsorship of New Deal art programs continued into 1943, when a thriving economy resulting from the country's entry into World War II (following Japan's attack on Pearl Harbor on December 7, 1941) made them redundant. Employment rose and industrial production soared as the country went to work to meet the demands of the war machine. Although prior to 1940 African Americans were routinely excluded from defense industry jobs, the situation changed dramatically when President Roosevelt issued Executive Order No. 8802 in 1941. Thereafter, large numbers of blacks joined that workforce, as did many women. The military, however, remained racially segregated until 1948, so that while African Americans served in the military in large numbers, they were relegated to all-black units. Not surprisingly, many war-related images were produced during this period. These focused on laborers in the defense plants and navy yards, where African Americans were often assigned the most menial jobs (see cat. no. 44a), and on uniformed soldiers patriotically going off to war or jubilantly returning home (see cat. nos. 42, 47). As with their renderings of daily life, these war pictures are described from an African-American perspective and sometimes contain underlying commentaries on racial issues.

During the war, contemporary American artists formed groups like Artists for Victory, Inc., a national organization under whose umbrella members of various other arts organizations could exhibit together. By its very name,

the organization meant to convey the message that artists were patriots who through their art could support the nation's war effort (fig. 3). Underlying this message was the belief that the arts were an indispensable part of a free society and the fervent hope that the public and the government would continue to support American artists on a broad scale, as the New Deal programs had done.

Among the first exhibitions sponsored by Artists for Victory, Inc., was the wartime art competition held at The Metropolitan Museum of Art from December 7, 1942 (the first anniversary of Pearl Harbor), to February 22, 1943 (see fig. 4 on p. 17). Whether this nationally juried exhibition, or any of the subsequent exhibitions sponsored by Artists for Victory, Inc., resulted in tangible gains for contemporary artists in American society can be debated. But one clear beneficiary was the Metropolitan Museum, which acquired works by forty-one of the forty-three award winners.[15] Not only did the Museum's purchases include important works by Peter Blume (1906–1992), Alexander Calder (1846–1923), John Steuart Curry, and Marsden Hartley (1877–1943), to name just a few, but more historically important was the acquisition of two works by African-American artists—Jacob Lawrence's gouache *Pool Parlor* (cat. no. 41) and Richmond Barthé's (1901–1989) bronze sculpture *Boxer*, of 1942—making these artists the first African Americans to be represented in the Metropolitan's collections. The following year (in 1943), sixteen more works (all WPA prints and watercolors) were added to the Museum's holdings. Since then, the number has swelled to about five hundred works in all media (paintings, sculpture, drawings, prints, photography, and textiles), a large percentage of them made for the WPA.

Unfortunately for the artists who had thrived under the New Deal, the end of that program in 1943 also meant the end—for lack of financial backing—of most of the community-based art projects, schools, and workshops that had

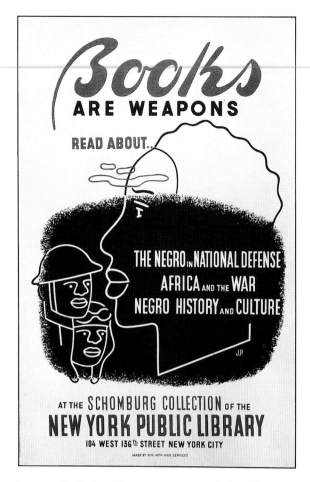

Figure 3. *Books Are Weapons*, ca. 1941–43. Color silk-screen poster. New York City WPA War Services

bridge the divide and have successful long-term careers. In part, their success was based on the fact that their styles were unique and compelling and had universal appeal that transcended racial lines. But in addition, their work was categorized as "paintings"—albeit paintings on paper—as opposed to the "secondary" medium of printmaking, and was therefore taken more seriously. As for the rest, they were largely forgotten until decades later, when a few art historians, dealers, and private collectors renewed interest in this period of American art and started to resurrect the names of neglected artists;[17] recovering their work, however, has been a much greater challenge.

When the New Deal programs terminated—in the midst of the war—hundreds of thousands of works of art that had been produced had to be dispersed in a matter of months. Without a systematic plan and with the more pressing needs of the war effort to contend with, much of the art was abandoned in storage depots, where it was neglected for decades and eventually lost or destroyed. After the war, little attention was paid to this material because, as noted by the art historian Francis V. O'Connor, the New Deal art programs were now viewed by many as

hotbeds of Marxist ideology and Communist subversion—ideas already used against them in the 1930s—[which] reduced New Deal art to 'poor art for poor people.' And, the depiction of poor people was considered subversive illustrations of national weakness. Postwar artistic tendencies such as Abstract Expressionism eclipsed art of social concern and depictions of the 'American scene.' New Deal art was forgotten and by the late fifties, the Projects were a dim memory.[18]

Only a relatively small percentage of the over 360,000 works of art produced for the WPA were ever deposited in museum collections.[19] Generally, these museums were located in cities where the WPA centers had been most active. In

provided materials and exhibition opportunities. Even so, expectations were high, as the painter and art historian James A. Porter (1905–1970) wrote in 1943: "The opportunities afforded . . . through the WPA . . . raise the hope that equal opportunities will soon appear through private and commercial patronage."[16] The reality of the situation, however, was another matter. Without these resources, many African-American artists who had begun to make progress in gaining access to museums, galleries, collectors, and exhibition venues found themselves once again ignored by the mainstream art world. Only a very few—Romare Bearden (see cat. no. 24) and Jacob Lawrence (see cat. nos. 18, 30, 41), to name two of the best known—were able to

Figure 4. Installation view of "Artists for Victory," an exhibition held at The Metropolitan Museum of Art, 1942–43

New York, the site of the largest WPA activity, The Metropolitan Museum of Art acquired a total of 1,960 works from various WPA projects. One hundred eighteen prints were purchased in 1940; the rest (1,842 paintings, drawings, prints, and sculptures) were received as gifts in 1943. Among these were sixteen works on paper (prints, gouaches, and watercolors) by five African-American artists—Charles Henry Alston, Samuel Joseph Brown Jr., Raymond Steth, Dox Thrash, and once again, Jacob Lawrence (all artists represented in this catalogue).

Since beginning this new collecting chapter in its history in 1942, the Museum has steadily acquired representative works by African-American artists dating from the 1920s to the present. These works are held in five separate curatorial departments—Modern Art, Drawings and Prints, Photographs, American Paintings and Sculpture, and American Decorative Arts—with the greatest share accessioned to the Department of Modern Art. Forty percent of these works fall within the sixteen-year time frame of this exhibition (1929 to 1945), a number that was greatly augmented by the remarkable

gift in 1999 from Reba and Dave Williams. Of the 204 prints received from that collection—all by African-American artists—146 were made during these years.

Collecting since the 1970s, the Williamses have focused primarily on American prints from the 1930s and 1940s. As of 1993, when a portion of their collection traveled in an exhibition titled *Alone in a Crowd*, their holdings included works by some one thousand artists, of whom approximately 4 percent were African Americans. Since the early 1990s, they have made a special effort to collect prints by African Americans.[20] This endeavor has illustrated the scarcity of such material, often the result of the WPA's stipulation that prints be made in editions no larger than twenty-five (and often smaller) and that artists keep no more than three impressions of each print, and the general abandonment of WPA prints after 1943. Despite these obstacles, the Williams collection includes rare examples by the best-known artists of the period, as well as works by artists who were waiting to be "rediscovered." The dedicated efforts of these two collectors to thoroughly catalogue, publish, and circulate this

art over the course of the past decade has done much to find these artists a new audience.

It is our intention that the exhibition and this publication, which celebrate this recent gift to the Metropolitan Museum, also raise awareness of the accomplishments of African-American artists during the New Deal–World War II era. In such historically grounded shows, we are able to assess the unique vision of a group of artists who recorded their times with precision and sensitivity. Seeing their accounts of life in America as experienced by African Americans, we come to realize what has been missing from the history books and from the story of modern art.

1. Lisa Gail Collins, letter to author, August 4, 2002.

2. Lowery Stokes Sims, "African-American Artists as Printmakers," in *Alone in a Crowd: Prints of the 1930s–40s by African-American Artists, from the Collection of Reba and Dave Williams* (exh. cat., [New York]: American Federation of Arts, 1993), p. 3.

3. Leslie King-Hammond, "Black Printmakers and the W.P.A.," in *Alone in a Crowd*, p. 11.

4. Brendan Gill, "On Astor Row," *The New Yorker*, November 2, 1992, p. 52, quoted in Sharon F. Patton, *African-American Art* (Oxford: Oxford University Press, 1998), p. 111.

5. Barbara Rose, *American Art Since 1900* (New York: Praeger Publishers, Inc., 1975), p. 93.

6. As Francis V. O'Connor has pointed out, "There is no easy way to find the exact number of WPA/FAP artists employed on that project between August 1935 and c. 1943" because of the complexities of the record keeping and published lists, which often included office staff in the total number of WPA employees (per correspondence with author, July 5, 2002). According to O'Connor's research, 3,500 artists in the fine and practical arts were employed in 1936 alone, at the peak of WPA employment. Since the totals for the other years varied considerably and in some cases do not exist at all, an exact figure for the entire 1935–43 period is impossible to ascertain. The higher employment figure of 5,000 is an estimate that tries to take into account the other seven years of the WPA (this figure is used in *New York/Chicago: WPA and the Black Artist* [exh. cat., New York: Studio Museum in Harlem, 1978], unpag.). The estimated salary of about twenty-three dollars is based on a consensus of published figures, which also vary. In comparison, the average weekly earnings for production workers in manufacturing in the late 1930s was also about twenty-three dollars.

7. These numbers are based on Francis V. O'Connor's publication *Federal Support for the Visual Arts: The New Deal and Now . . .* (Greenwich, Conn.: New York Graphic Society, 1969), pp. 28–29, 54.

8. Reba and Dave Williams, "The Rarity of Prints by African-American Artists," in *Alone in a Crowd*, p. 8.

9. Description by Lisa Fischman of WPA/FAP's national director Holger Cahill's vision for the project in "Exhibition Publication: Experiment in Balance," in *The Meyer Family Collection: Prints from the New York Federal Art Project* (exh. cat., Buffalo: University of Buffalo Art Gallery, 1998); accessed online, July 10, 2002: http://www.artgallery.buffalo.edu/meyer.html.

10. Rose, *American Art Since 1900*, pp. 105–6.

11. Commentary by Ellen Sragow on a symposium discussion between artists Robert Blackburn, Ernest Crichlow, Riva Helfond, Ronald Joseph, Hughie Lee-Smith, and Raymond Steth, in "Black Printmakers and the WPA: A Symposium," *Tamarind Papers: A Journal of the Fine Print* 13 (1990), p. 74.

12. Hughie Lee-Smith, quoted in ibid., p. 75.

13. Nancy E. Rose, *Put to Work: Relief Programs in the Great Depression* (New York: Monthly Review Press, 1994), p. 102, quoted in Dewey F. Mosby, ed., *Life Impressions: 20th-Century African American Prints from The Metropolitan Museum of Art* (exh. cat., Hamilton, N.Y.: Picker Art Gallery, Colgate University, 2001), p. 35.

14. Mosby, *Life Impressions*, p. 35.

15. Two of the artists—Ivan Albright and John Rogers Cox—opted to receive medals rather than accept the purchase prize money offered by the Museum.

16. James A. Porter, *Modern Negro Art* (New York: Dryden Press, 1943), p. 133, quoted in Leslie King-Hammond, *Black Printmakers and the W.P.A.* (exh. cat., Bronx: Lehman College Art Gallery, City University of New York, 1989), p. 6.

17. The first exhibition of New Deal art was held at the Ira Smolin Gallery in 1961. This was followed by a 1966 exhibition at the University of Maryland, organized by Francis V. O'Connor. O'Connor's pioneering study *Federal Support for the Visual Arts* led the way for more specific studies about African-American artists in the New Deal programs. See, for example, *New York/Chicago: WPA and the Black Artist* (1978); King-Hammond, *Black Printmakers and the W.P.A.* (1989); *Alone in a Crowd* (1993); and *Life Impressions* (2001).

18. Quote from Francis V. O'Connor, transcript of remarks at a panel discussion titled "Who Owns WPA Prints?" held at the Print Fair, New York, November 4, 2000, accessed online, July 10, 2002: http://www.printdealers.com/learn_whoowns.cfm.

19. See O'Connor, *Federal Support for the Visual Arts* (pp. 205–7) for a complete list of institutions receiving art from the WPA between January 1 and April 30, 1943.

20. Reba and Dave Williams, "Rarity of Prints by African-American Artists," p. 7.

1. Cultural Heritage and Identity

The beliefs of many African-American artists working in the 1930s and 1940s were informed by the issues of cultural heritage raised by noted intellectuals of previous generations. These issues related to choices about what constituted appropriate training, artistic sources, and subject matter for their art.

At the beginning of the twentieth century, the eminent historian and politician W. E. B. Du Bois (1868–1963) identified what he termed the "double consciousness" of being, simultaneously, "an American" and "a Negro" (meaning people linked to Africa): "One ever feels his twoness . . . two souls, two thoughts, two unreconciled strivings," as though straddled between two cultures.[1] Du Bois advocated Pan-Africanism, a political movement that sought to unite all black people with Africa, regardless of geographical, political, religious, or cultural differences.[2]

In the 1920s, the importance of Africa as part of the ancestral legacy of African Americans was promoted by Alain LeRoy Locke, the leading educator and interpreter of the Harlem Renaissance. Locke's popularization of the phrase "the New Negro" (used as the title of his 1925 anthology of essays) was meant to renew racial pride in black Americans.[3] In particular, he charged African-American artists to develop "a school of Negro art" that would create "a local and racially representative tradition" on which they could draw in their portrayal of African-American subjects. In this endeavor, African art was seen as the most significant source of inspiration.[4]

In many ways, African-American art, in expressing aspects of ethnic identity and artistic heritage, ran counter to established traditions in American art, as well as against current trends in modern Western art. Two pictures in this section, an oil painting by Lois Mailou Jones (cat. no. 1) and a watercolor study by William Henry Johnson (cat. no. 2), reflect the European training these artists received at the beginning of their careers. Study abroad was generally popular with American students who sought the cachet of the European academies, and racial tolerance—particularly in Paris—provided an additional incentive for African Americans. While both Jones and Johnson later developed mature styles that consciously made reference to African

art and black folk art (see cat. no. 42), respectively, their early work followed the conventions of Western traditions in both subject matter (a still life and a street scene) and technique. These works transcend racial identity, although Johnson's travels in Europe and North Africa, where he painted the view of Tunisia (cat. no. 2), may have been motivated by Pan-African ideals.

In marked contrast to these paintings, the three prints in this section, by Wilmer Angier Jennings, David Ross, and Charles Wilbert White (cat. nos. 3–5) all engage in a conscious dialogue with African art. Jennings's reference is unmistakable, as he prominently features an African sculpture in the center of a complex still life. For Ross and White, the connection is based not on subject matter but on stylistic similarities. Emulating the highly stylized, blocky figuration of some African sculptures, they produced printed figures that look as if they were carved from wood. Although many European and American artists of the late 1910s to 1930s—including Pablo Picasso, Constantin Brancusi, the German Expressionists, and Max Weber, to name but a few—also used African sculpture for their work, such choices by African-American artists held special significance as proud declarations of their African heritage.

LMM

1. W. E. B. Du Bois, *The Souls of Black Folk: Essays and Sketches* (Chicago: McClurg, 1903), quoted in Sharon F. Patton, *African-American Art* (Oxford: Oxford University Press, 1998), p. 106.
2. At the turn of the century, Pan-Africanism led some African-American artists to look to ancient Egyptian art as a model for depicting contemporary figures. See Patton, *African-American Art*, p. 109.
3. The phrase "New Negro" was already used in the late nineteenth century to refer to the conditions imposed on African Americans from the days of slavery. In 1900, Booker T. Washington incorporated this potent phrase into the title for his book *A New Negro for a New Century*.
4. Locke, however, mistakenly interpreted African art as mainly decorative and "reduced Africa to a cultural trope for the purpose of promoting racial authenticity. For the next ten years, Locke characterized Africa in simple formalist terms, ignoring the real complexity of its culture." Patton, *African-American Art*, pp. 101, 116.

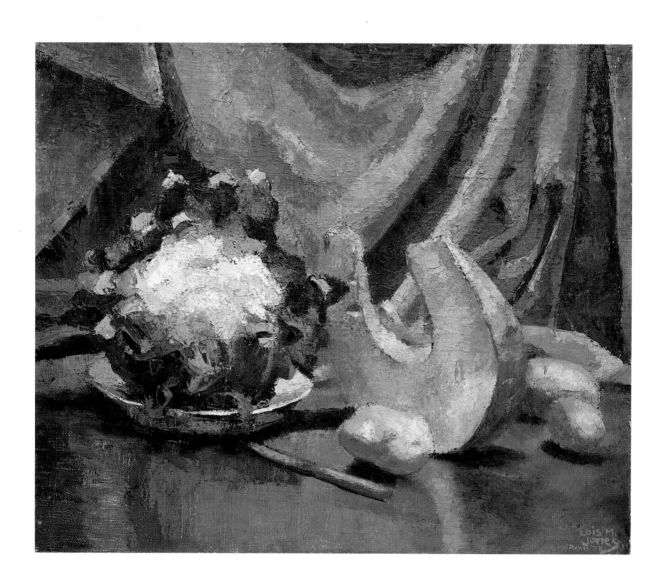

Lois Mailou Jones
1905–1998

1. *Cauliflower and Pumpkin*
1938
Oil on canvas
21⅜ x 25½ in. (54.3 x 64.8 cm)
Gift of Max Robinson, 1981
1981.535

In 1930, three years after graduating from the
School of the Museum of Fine Arts, Boston, where
she had majored in design, Lois Mailou Jones joined
the newly founded art department at Howard
University, Washington, D.C. Along with depart-
ment chair James Vernon Herring (1887–1969),
the painter and art historian James A. Porter
(1905–1970), and the printmaker James Lesesne
Wells (see cat. nos. 31, 35), Jones, who was hired
as a professor of design and watercolor painting,
developed the curriculum for this dynamic and
influential art department.

In September 1937, Jones went to Paris for her
first sabbatical, having been awarded a fellowship
to study painting at the Académie Julian. During
her nine months at the academy, she produced
about forty works. Her subjects, which were pri-
marily plein-air landscapes and street scenes,
reveal her absorption of French Impressionism
and her admiration for the Post-Impressionists,
especially, Paul Cézanne.

Cauliflower and Pumpkin, one of the few still
lifes Jones executed in Paris, is a skillful explo-
ration of light, shadow, and composition. Rendered
in a painterly manner with a fresh palette, the
painting exemplifies Jones's expressive sensitivity.
Praising the vibrancy of her early work, Porter
wrote: "She has a commanding brush that does not
allow a nuance of the poetry to escape. Sensuous
color delicately adjusted to mood indicates the
artistic perceptiveness of this young woman."[1]

After her year in Paris, Jones promptly returned
to Howard University, where she continued to teach
until 1977. Her students included Elizabeth Catlett
(see cat. no. 29) and David Driskell (b. 1931).

1. James A. Porter, *Modern Negro Art* (New York: Dryden
Press, 1943), p. 125.

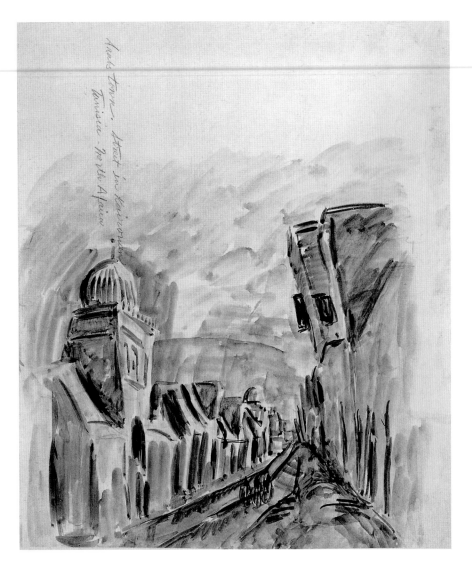

William Henry Johnson

1901–1970

2. *Street in Kairouan, Tunisia*

ca. 1932
Watercolor and pencil on paper
23½ x 19¾ in. (59.7 x 50.2 cm)
Purchase, The Louis and Bessie Adler Foundation Inc.
Gift, 1996
1996.182.b

Born in Florence, South Carolina, William H. Johnson moved to New York City in 1918. After five years at the National Academy of Design, from 1921 to 1926, where he studied with the painters Charles Webster Hawthorne (1872–1930) and George Luks (1867–1933), he spent the next twelve years based in Europe. Living first in France and later in Scandinavia, he embraced the lessons of European modernism and was drawn, in particular, to Expressionism. In 1930, Johnson married Holcha Krake (1885–1944), a Danish weaver and ceramist, and for the next eight years the interracial couple traveled and exhibited their work on both sides of the Atlantic.

In 1932, Johnson and Krake went to Tunisia, where they studied local art traditions, including wool dyeing, weaving, and pottery. In *Street in Kairouan, Tunisia*, part of a vibrant series of street scenes in watercolor, three figures are shown ambling down a quiet street in the holy Islamic city, outsized by the dramatic architecture that flanks the road. The picture reflects the influence of both Impressionism, in its fleeting colors of sunlight, and Expressionism, in its spontaneity and distortion of scale. On the reverse side of the sheet is another watercolor street scene of Kairouan, in horizontal format.

Seven years after their sojourn in Tunisia and the year following their relocation to the United States, Johnson and Krake had a joint exhibition of the watercolors, woodcuts, tapestries, and ceramics that had been inspired by their travels. Held at the Artists' Gallery in New York, their eclectic show powerfully displayed the visual lessons they had learned both together and apart while experiencing North Africa for the first time. (See also cat. no 42.)

Wilmer Angier Jennings

1910–1990

3. *Still Life with Fetish*

1937
Wood engraving
Sheet: 15⅞ x 11⅛ in. (40.3 x 28.3 cm)
Image: 10 x 8 in. (25.4 x 20.3 cm)
Gift of Reba and Dave Williams, 1999
1999.529.74

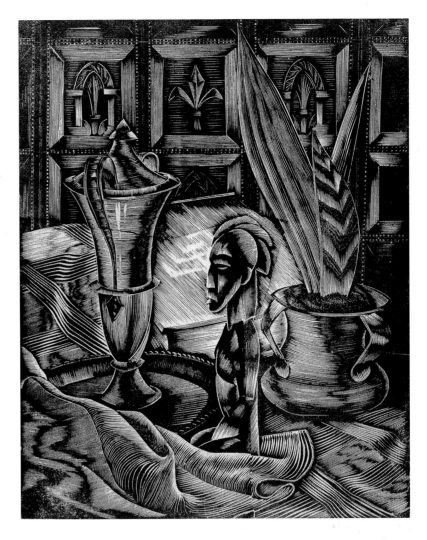

Wilmer Angier Jennings was born in Atlanta, Georgia. There he attended Morehouse College, where he studied with Hale Woodruff (see cat. nos. 9, 13). Woodruff introduced Jennings to the principles of modernism, which he had studied in Paris during the late 1920s. In the early 1930s, Jennings produced two important murals whose theme was the African-American experience in America. The first, for which he was Woodruff's assistant, was the WPA-sponsored *The Negro in Modern American Life: Agriculture and Rural Life, Literature, Music, and Art* (1934), for the David T. Howard Junior High School in Atlanta, and the second, titled *The Dream*, depicted the contributions of African-American labor to the southern economy (both destroyed).[1]

After graduating from college, Jennings moved to New England to study at the Rhode Island School of Design in Providence and was hired by the Rhode Island WPA. The wood engraving *Still Life with Fetish* is an example of his WPA work. The composition includes a book, a potted plant, and an urn. Carefully positioned on swathed fabric in front of an elaborately paneled wall, the objects, typical of the still-life genre, connote learning, life, and death. Departing from genre conventions, however, Jennings included a small wood sculpture from West or Central Africa. Perhaps drawing on his knowledge of Woodruff's extensive collection of traditional African art and his teachings about European modernists' finding inspiration in the material culture of Africa, Jennings placed the African statue at the center of what is essentially a Western still life. (See also cat. no. 23.)

1. Claude L. Elliot and Corrine Jennings, *Pressing On: The Graphic Art of Wilmer Jennings* (exh. cat., Providence: Museum of Art, Rhode Island School of Design, 2000), p. 17.

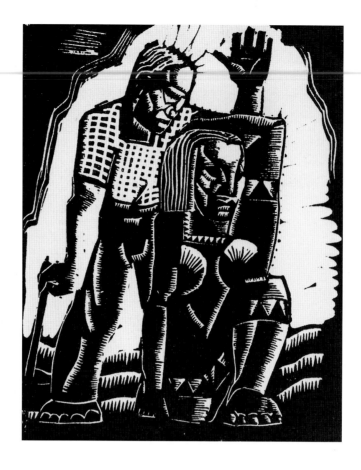

David Ross

1908–1980

4. *Two Figures*

1938
Woodcut
Sheet: 5½ x 4½ in. (14 x 11.4 cm)
Image: 5 x 4 in. (12.7 x 10.2 cm)
Gift of Reba and Dave Williams, 1999
1999.529.138

From 1935 to 1943, the WPA sponsored projects that gave many artists their first opportunity to work full-time on their art, to share their expertise with other artists, and to exhibit their work. The community art centers established by the WPA's Federal Art Project (FAP) were not only places where children, teenagers, and adults could receive training in the arts, they also provided jobs for artists. The South Side Community Art Center in Chicago—one of the few WPA-sponsored art centers still in existence today—was dedicated in 1941, with a nationally broadcast ceremony in which Eleanor Roosevelt was an important participant.

David Ross was central to the establishment of the center and was its first exhibition director. In this rare print—Ross was primarily a painter and sculptor— he makes full use of the expressive capacities of the woodcut medium. The composition resembles a large stage. The dark corners, like drawn curtains, reveal a violent scene of a man poised to strike a seated woman with one hand and holding a stick in the other. Composed of angular lines and geometric shapes, the monumental female figure remains a mystery. Her solemn face looks like a traditional West African mask; her stylized body resembles a wood sculpture; and her large feet, like those of her antagonist, suggest a nonhuman source.

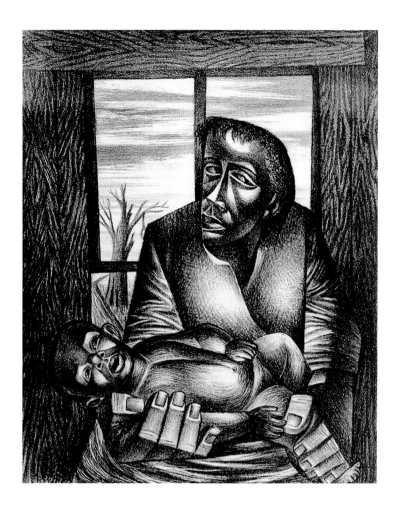

Charles Wilbert White
1918–1979

5. *Hope for the Future*
1945
Lithograph
Sheet: 18⅞ x 12⅝ in. (47.9 x 32.1 cm)
Image: 13¼ x 10⅝ in. (33.7 x 27 cm)
Gift of Reba and Dave Williams, 1999
1999.529.183

Charles Wilbert White worked under the auspices
of the WPA at the South Side Community Art
Center in Chicago from 1939 to 1940. Inspired by
the lively discussions about socially and politically
engaged art and by the powerful work of the mod-
ern Mexican muralists, White committed himself
to expressing through his art the struggles and
achievements of African Americans. Initially, he
focused on the accomplishments of heroic figures,
producing, in the early 1940s, epic murals that
portrayed the dramatic events of black history. By
the mid-1940s, however, his focus had shifted to
the daily rituals of everyday people in contemporary
life. White envisioned his work—which included
drawings, paintings, and prints—as "aiming to
show the black race in all of its majesty, its tri-
umph, its weakness, and even its downfall."[1]

Made in 1945, when White was an artist in resi-
dence at Howard University, in Washington, D.C.,
Hope for the Future is a gripping portrait of a
black mother cradling her baby. In its portrayal
of a modern Madonna and child, the print echoes
the work of White's then wife, Elizabeth Catlett
(cat. no. 29). The tone of White's print, however,
contrasts starkly with Catlett's, as her *Mother and
Child* evokes intimacy and hope, while his, ironi-
cally titled, expresses alienation and suffering.

A maternal figure, with a wary, despairing gaze,
is shown holding her infant son. Although physi-
cally linked, the mother and child avoid eye contact

and appear emotionally unconnected. Outside, in the distance, a tree, the traditional symbol of life, stands dead, a noose hanging from its branches. This harrowing work suggests that while the mother is strong, as exemplified by her massive hands, she will not be able to protect her son from a future of racism, violence, and oppression.

White never lost his deep pessimism about the future. Writing about art and society, he later asked:

> Where is the hope and faith in the future? Where is the artist striking a blow against war, oppression and proclaiming the rights of man, the monumental dignity of man's history and the promises of a life of brotherhood and unity? Where is the alliance between the artist and the worker? Where is the art that speaks courageously, without fear? Where is the realistic portrayal of life? The answer is tragically simple, they are a silent voice in this struggle.[2]

1. Quoted in David Driskell, *The Other Side of Color: African American Art in the Collection of Camille O. and William H. Cosby Jr.* (San Francisco: Pomegranate, 2001), p. 128.
2. Charles Wilbert White, "A Negro Speaks," transcript of 1950s interview, microfilm reel 3190, p. 488, Archives of American Art, Smithsonian Institution, Washington, D.C.

2. Faces

Portraiture is a centuries-old subject in Western art and has continued to be a popular way of presenting not only a physiological and psychological description of the sitter but also a portrait of the times. While artists of the Middle Ages and the Renaissance were often commissioned to paint formal portraits of powerful patrons with religious or political connections, later commissioned portraits, from the eighteenth and nineteenth centuries, featured privileged and wealthy socialites. Although such official portraiture continues today, modern and contemporary artists in general have assumed greater artistic freedom in their choice of sitter and manner of depiction. Often they select someone from their immediate circle of family or friends, and, frequently, themselves, but sometimes it is the anonymous stranger whose striking appearance attracts their attention.

Beginning in the 1910s and 1920s, with the artists and photographers of the Harlem Renaissance, and continuing into the 1940s, African-American artists consistently recorded the faces of African Americans, a subject that until then had seldom appeared in American art. While some portraits are large, formal oil paintings, a greater number are executed on paper, in watercolor, and a variety of print media. Some depict full-length figures or complex settings, such as Ronald Joseph's studio portrait of his fellow printmaker Robert Blackburn (cat. no. 8), but many more are small in size and tightly focused on the sitter's head and shoulders. These intense close-ups fill the space, commanding even greater attention than their size relative to the sheet would indicate.

Among the smallest, but most compelling, works in this section is the dignified self-portrait by Horace Pippin (cat. no. 6), who, though challenged by physical and financial hardship during his life, faces the viewer unflinchingly. Four other self-portraits appear in the catalogue—by Albert A. Smith, Samuel Joseph Brown Jr., Hughie Lee-Smith, and Palmer Hayden (cat. nos. 7, 10, 33, 36). The large war epic by John Woodrow Wilson (cat. no. 45) may also include a self-portrait.

LMM

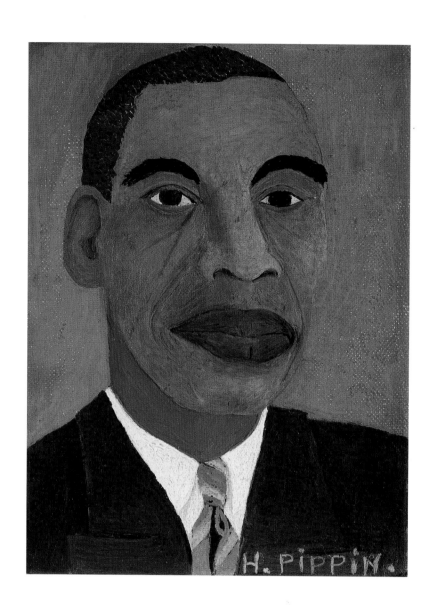

Horace Pippin
1888–1946

6. Self-Portrait
1944
Oil on canvas, adhered to cardboard
8½ x 6½ in. (21.6 x 16.5 cm)
Bequest of Jane Kendall Gingrich, 1982
1982.55.7

In 1917, the year the United States entered World War I, Horace Pippin enlisted in the National Guard, where he served as an army corporal. Stationed in France, in a black regiment—with the requisite white officers—Pippin kept illustrated journals of his military experiences. One year later, after being shot in the right shoulder and honorably discharged, he moved back to his birthplace in West Chester, Pennsylvania.

Pippin had always loved to draw. As therapy for his shattered right shoulder and arm, he began to experiment with different materials. Sometime in the late 1920s, he turned to oil painting, using his strong left arm to guide his weaker right one. Because painting was so physically demanding for him, Pippin made only three or four paintings a year over the next decade. When asked how he chose his subject matter, he replied, "Pictures just come to my mind, and I tell my heart to go ahead."[1]

About 1937, Pippin's pictures started to attract local interest, and soon after they gained national attention. In 1938, four of his works were included in the important exhibition "Masters of Popular Painting—Artists of the People," curated by Holger Cahill (1887–1960), national director of the WPA/FAP, and held at the Museum of Modern Art, New York. Like the rural scenes depicted by the self-taught painter Grandma Moses (Anna Mary Robertson Moses, 1860–1961), Pippin's vibrant paintings were praised for their honesty, originality, and expressiveness.

Typically, Pippin's paintings depict everyday events, historical figures, and religious themes. This painting is one of only two self-portraits the artist executed during his career. In this painting, of 1944, the artist presents himself as a professional, middle-aged man. Dressed in a jacket, shirt, and tie, he is poised and self-possessed. It seems clear that Pippin wanted this visual autobiography, created two years before his death, to suggest a chapter of his life in which he was deeply self-aware and utterly self-confident.

1. Horace Pippin, quoted in Selden Rodman, *Horace Pippin: A Negro Painter in America* (New York: Quadrangle Press, 1947), p. 4.

Albert A. Smith

1896–1940

7. *Self-Portrait with Hat and Pipe*

1929
Lithograph
Sheet: 12⅞ x 10 in. (32.7 x 25.4 cm)
Image: 9½ x 6½ in. (24.1 x 16.5 cm)
Gift of Reba and Dave Williams, 1999
1999.529.147

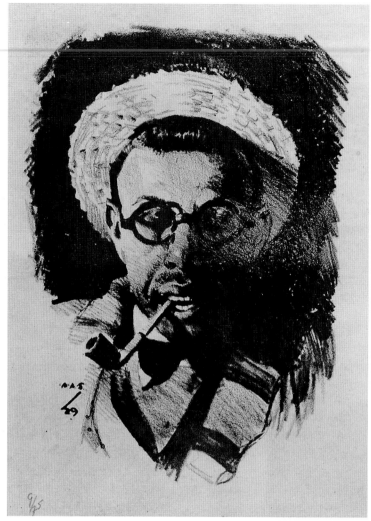

In 1915, Albert A. Smith became the first African American to enroll at the National Academy of Design in New York. After serving in the military during World War I, he returned to the academy to study easel painting, mural painting, and etching. His mentors were Kenyon Cox (1856–1919), Joseph Pennell (1857–1926), and William Auerbach-Levy (1889–1964). After graduating, Smith moved to Europe in 1920, where he remained until his early death at age forty-three.

Based primarily in Paris, Smith worked as "a musician by night and a struggling artist by day," supporting himself as a guitarist and banjo player while he pursued his career in the visual arts.[1] Keeping up with his professional contacts in New York, he contributed illustrations to the magazine *The Crisis*, published by the National Association for the Advancement of Colored People (NAACP), and to the National Urban League's *Opportunity* magazine. For these influential organs of the Harlem Renaissance, Smith produced work that illustrated either the social injustices faced by African Americans or the glories of their African past.

Beginning in 1922, Smith began a series of portraits of famous people of African descent. Now housed at the Schomburg Center for Research in Black Culture in New York, this series, which includes portraits of such leaders as the Haitian liberator Toussaint-Louverture (ca. 1743–1803),

the American abolitionists Frederick Douglass (1817–1895) and Harriet Tubman (ca. 1820–1913), and the French novelist René Maran (1887–1960), celebrates the achievements of members of the African diaspora.

In this idiosyncratic self-portrait, made seven years after he had started the commemorative portrait series, Smith depicts himself as a somewhat eccentric, bohemian artist sporting a straw summer hat and bow tie and clenching a pipe in his teeth. (See also cat. no. 37.)

1. Arthur Schomburg, letter to George Haynes, 1929, quoted in Theresa Leininger-Miller, *New Negro Artists in Paris: African American Painters and Sculptors in the City of Light, 1922–1934* (New Brunswick, N.J.: Rutgers University Press, 2001), p. 209.

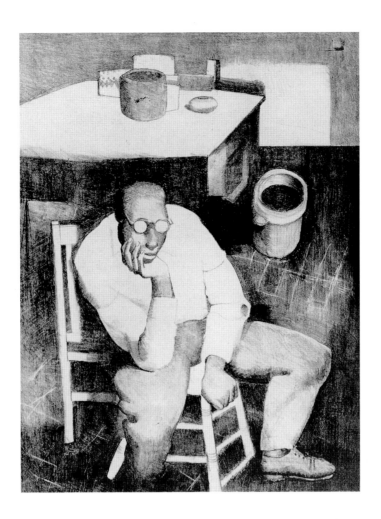

Ronald Joseph

1910–1992

8. *Robert Blackburn*

ca. 1937
Lithograph
Sheet: 19⅞ x 14⅞ in. (50.5 x 37.8 cm)
Image: 15¾ x 12⅛ in. (40 x 30.8 cm)
Gift of Reba and Dave Williams, 1999
1999.529.106

Born on the island of St. Kitts in the West Indies, Ronald Joseph moved as a child with his family to New York City. As a high school student in Manhattan, Joseph was highly praised for his creative talents. In 1929, he was honored as "the most promising" young artist in New York City's school system, and sixty of his watercolors and drawings were displayed at The Metropolitan Museum of Art.[1]

During the 1930s, Joseph studied with Riva Helfond (1910–2002), a white printmaking instructor at the WPA-sponsored Harlem Community Art Center. Experimenting with lithography and etching, as well as woodblock and silkscreen printing, Joseph explored the techniques of printmaking alongside his friend Robert Blackburn (see cat. nos. 26, 39), the subject of this lithograph.

The casually cool teenager is portrayed seated in the foreground of a spare printmaking studio, which, though without work or equipment, seems poised for a flurry of artistic activity. Once owned by Helfond, the print reveals the hand of a talented student who would later complete the circle by teaching at the same art center where he had studied.

1. "Art: Charwoman's Son." *Time Magazine*, June 24, 1929, p. 42.

31

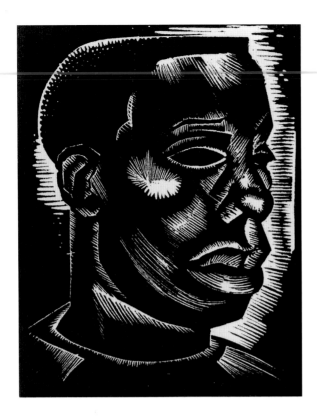

Hale Woodruff

1900–1980

9. *Young Buck*
ca. 1938
Woodcut
Sheet: 6¾ x 5⅝ in. (17.1 x 14.3 cm)
Image: 4¼ x 3¼ in. (10.8 x 8.3 cm)
Gift of Reba and Dave Williams, 1999
1999.529.202

After winning a 1926 Harmon Foundation award
for his painting, Hale Woodruff traveled to Paris
to study modern art theory and technique. Arriving
at the City of Light, he joined the lively coterie of
African-American artists, musicians, and writers
who formed what Woodruff would later call the
"Negro Colony." Palmer Hayden found him a room,
and Woodruff promptly enrolled at the Académie

Scandinave and the Académie Moderne. In France,
Woodruff also had contact with Henry Ossawa
Tanner and Alain Locke.

After four years studying modern art, particu-
larly Cubism, in France, Woodruff returned to the
United States. In 1931, he accepted an offer to
develop a fine arts curriculum for the Atlanta
University system. The devoted and influential
teacher remained at this post until 1945. As part of
his pedagogical mission to make art more accessible
to students and to their communities, Woodruff
added printmaking classes to the university's course
offerings. He also traveled to Mexico City in the
mid-1930s to study the work of Diego Rivera (1886–
1957). Woodruff believed that the modern Mexican
muralists, such as Rivera, had something important
to teach him as an artist and a teacher about creat-
ing accessible art that both encouraged knowledge
of history and fostered a positive self-image.

The printmaking classes that Woodruff taught
at Atlanta University focused on woodcut and
linoleum cut. Local people and local life were often
the subjects of this work. This small print may have
been shown to his students. Composed of deep,
expressive lines, *Young Buck* depicts a young man's
head in three-quarter view. Although its title evokes
the denigrating stereotype of a brutally strong black
man, the work does not suggest this caricature.
Instead, with its highly stylized eyes and sense of
volume and immobility, the young man's face resem-
bles an iconic African sculpture. This solemn work
reveals the artist's mastery of the tools of relief print-
ing. Lauding his fine skills as a printmaker, one art
historian asserted that Woodruff "used his carving
tools for linoleum cuts and woodcuts with the skill
and facility of a draughtsman in pen and ink."[1]
(See also cat. no. 13.)

1. Dewey F. Mosby, ed., *Life Impressions: 20th-Century
African American Prints from The Metropolitan
Museum of Art* (exh. cat., Hamilton, N.Y.: Picker Art
Gallery, Colgate University, 2001), p. 70.

Samuel Joseph Brown Jr.

1907−1994

10. *Self-Portrait*
ca. 1941
Watercolor, charcoal, and pencil
on paper
20¼ x 15⅜ in. (51.4 x 39.1 cm)
Gift of Pennsylvania WPA, 1943
43.46.4

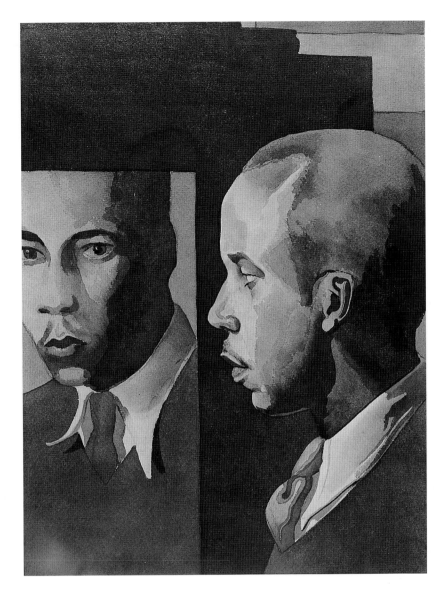

Trained at the Pennsylvania
Museum and School of
Industrial Art and at the
University of Pennsylvania,
where he received an M.F.A.
degree, Samuel Joseph Brown Jr.
was the first African-American
artist to be signed on to the
Public Works of Art Project
(PWAP), the first work-relief
program for artists during
the Depression. When the
PWAP was replaced by the
WPA/FAP in 1935, Brown
remained associated with
the national program's
Philadelphia chapter, work-
ing both as a painter for the
easel painting and watercolor
divisions and as a printmaker
at the Fine Print Workshop.

Acclaimed for his watercolors, Brown is known
for his unusual ability to confidently produce both
representational and nonrepresentational art simul-
taneously. Perhaps because of this versatility, the
artist received international attention when his work
was included in the 1939 exhibition "New Horizons
in American Art," organized by the Museum of
Modern Art, New York, in which he was the only
African American to be represented.

In this introspective self-portrait, the artist
gazes at his own image reflected in a mirror, study-
ing his face both to gain a deeper understanding
of himself and to reveal himself to his audience.
A significant departure from the more objective
exploration of the exterior world so common in
WPA-sponsored art, Brown's experimental self-
portrait delves into the complexities of the inte-
rior world.

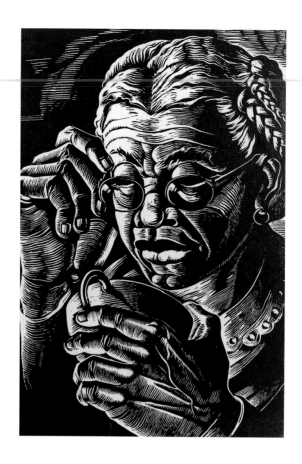

Elmer W. Brown

1909–1971

11. *The Fortune-teller*

ca. 1940s
Relief print
Sheet: 14⅛ x 9¾ in. (35.9 x 24.8 cm)
Image: 11⅜ x 7⅝ in. (28.9 x 19.4 cm)
Gift of Reba and Dave Williams, 1999
1999.529.13

The Fortune-teller is a vibrant portrait of an elderly woman intently reading the leaves at the bottom of her teacup. The extraordinary attention to detail in this compelling print suggests the complexity of the woman and her special gift for presaging the future. Made up of crisp, clear lines, the woman's strong hands, incised face, dainty collar, and prim braids suggest her strength, wisdom, and sense of propriety.

The subject of this relief print and its dramatic intensity befit the work of an artist involved in both printmaking and theater. Elmer W. Brown was a creative force in Cleveland, Ohio, where he moved, from Pittsburgh via Columbus, in 1929, at age twenty. During the Depression, he worked on the Cleveland WPA Mural Project and as both an art teacher and a set designer at Cleveland's famed Playhouse Settlement. Established in 1915, the Playhouse Settlement, a vital interracial community center now known as Karamu House, has encouraged the development of African-American artists for nearly a century.

During the 1930s and 1940s, Brown was part of a group of artists based at the center that included William E. Smith, Hughie Lee-Smith, and Charles L. Sallée Jr. (see cat. nos. 20, 33, 34). One primary objective of the Playhouse Settlement was to press "the Negro's creative abilities into the main stream [*sic*] of American life, thus removing him from the isolation which has been so costly to initiative and ambition."[1] This visionary institution is central to American art and African-American cultural history.

1. James A. Porter. *Modern Negro Art* (New York: Dryden Press, 1943), p. 128.

3. The South

More than half the artists in this catalogue were born, were educated, or worked in the South, where several prestigious black colleges and WPA art centers flourished during this period.[1] Many well-known African-American authors and musicians also hailed from the South, creating a rich cultural legacy that had an immediate impact on the arts in other parts of the country as well. For African Americans, however, the South also held horrific reminders of slavery, lynchings, Jim Crow laws, and widespread poverty. Prominent painters and printmakers, such as Hale Woodruff and Charles Henry Alston (see cat. nos. 9, 13, 14), as well as photographers hired by the WPA, recorded the substandard living conditions of southern blacks as acts of social commentary. Dealing with the controversial issue of the ongoing violence perpetrated against blacks in the South, Ernest Crichlow courageously depicted a terrifying scene of rape and racial hatred (cat. no. 15) that today remains one of the era's most memorable images. Denied basic civil liberties and economic opportunities, large numbers of people fled to the North between the two world wars, over a period of thirty years, in what is now known as the Great Migration (for further discussion, see p. 43).

Although some artists, such as Dox Thrash from Georgia and Raymond Steth from Virginia, eventually established themselves in northern cities—both were prominent in the Fine Print Workshop of Philadelphia—their memories of the South remained strong in their art. Throughout their careers, they produced both urban and rural scenes, allowing the more pleasant recollections of life in the segregated South to govern their choice of imagery. Thrash's woman with a parasol, dressed in her Sunday best (cat. no. 16), may be an homage to his beloved mother (who died in 1936) and, like his print *Glory Be* (cat. no. 28), suggests the important place of religion in southern communities. Steth's overly dramatic rendering of a hog roast (cat. no 17) and his detailed description of a religious pilgrimage (cat. no. 27), on the other hand, use humor tempered with empathy to convey the modest means of rural life. The naive drawings of Bill Traylor (cat. no. 12) have the wit and charm of American folk art, endowing even the simplest domestic scenario with deep humanity.

LMM

1. About the art collections of five black colleges in the South, see Richard J. Powell and Jock Reynolds, *To Conserve a Legacy: American Art from Historically Black Colleges and Universities* (exh. cat., New York: Studio Museum in Harlem; Andover, Mass.: Addison Gallery of American Art, 1999).

Bill Traylor

1854–1947

12. *Kitchen Scene, Yellow House*

1939–42
Pencil and colored pencil on cardboard
22 x 14 in. (55.9 x 35.6 cm)
Purchase, Anonymous Gift, 1992
1992.48

Bill Traylor was born into slavery on an Alabama cotton plantation in 1854. He continued to live and work there until the 1930s. In 1935, at the age of eighty-one, Traylor left his rural birthplace and moved to Montgomery, where he found little work and no permanent housing in the segregated Depression-era city. A young artist, Charles Shannon, "discovered" Traylor on a downtown sidewalk in 1939, where he was using pencils and a short stick as a straightedge to make drawings on scraps of cardboard. Over the next three years, Traylor produced more than one thousand drawings depicting scenes from the rural and city life that he directly experienced and imaginatively invented. Not until thirty years after his death did his work begin to be widely recognized by the American public. Today it is highly regarded and enthusiastically collected.

Farm life is a frequent subject of Traylor's narrative drawings. *Kitchen Scene, Yellow House* shows two scenes of farm life: in the upper register, a domestic interior, and in the lower, a picture of outdoor life. In the kitchen, a picture of tranquil harmony, a woman lights a lamp, a man ladles water, and a dog waits expectantly for scraps.

In contrast to the tranquil interior, the outdoor scene, which shows a simple yellow house with a blue roof, exudes turmoil; people and animals are active and in conflict. Drama and humor are typical of Traylor's cardboard drawings. Perhaps this one tells a comic tale of life both inside and outside the humble home.

Executed in pencil, the drawing reveals the hand of a self-taught artist. There is no illusion of depth and size is not proportionate, two compositional devices frequently employed by formally trained modern artists.

When asked why he began to make art, the elderly man who carried the knowledge of eight decades of hard living in his body and mind responded, "It just came to me."[1]

1. Quoted in Lowery Stokes Sims, "Bill Traylor: Inside the Outsider," in *Bill Traylor (1854–1949): Deep Blues*, ed. Josef Helfenstein and Roman Kurzmeyer (exh. cat., New Haven: Yale University Press, 1999), p. 92.

Hale Woodruff
1900–1980

13. *Going Home*
1935
Woodcut
Sheet: 15⅛ x 11¼ in.
(38.4 x 28.6 cm)
Image: 10 x 8 in.
(25.4 x 20.3 cm)
Gift of Reba and Dave Williams,
1999
1999.529.200

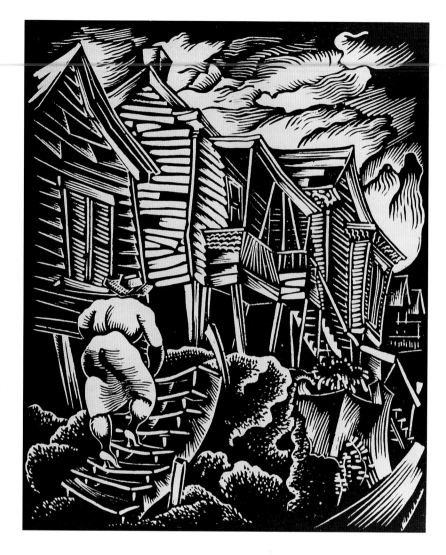

The Depression not only influenced the rise in print-making, it also influenced the subject matter of many prints. Social Realism, with its emphasis on images of working people struggling for freedom, equality, and dignity, was an important style and movement during this period of widespread economic hardship and labor unrest.

Hale Woodruff's *Going Home* combines aspects of Social Realism and American Regionalism. The print depicts a poor southern black neighborhood. Concerning his intentions in creating this work, Woodruff, who was an instructor for WPA programs in Atlanta, said he was "interested in expressing the South as a field, as a territory, its peculiar run-down landscape, its social and economic problems, the Negro people."[1]

In the print, a woman is returning home to her ramshackle and, most likely, segregated Atlanta neighborhood. Wearing a hat, a dress, and high-heeled shoes, she climbs the sagging steps to the first in a row of rickety homes. All the houses on this crowded street have fallen into disrepair. A foreboding sky hints that even more difficulties lie ahead. Perhaps suggesting their absent occupants, the houses appear broken and tired. The bold lines and strong contrasts that make up this image further emphasize the drama of this American scene.

Inspired by Social Realism, with its emphasis on using art as a vehicle to illuminate social problems, Woodruff asks, "Will this lone woman be able to rebuild this crumbling neighborhood? And, if not, who will?" (See also cat. no. 9.)

1. Quoted in "Black Beaux-Arts," *Time*, September 21, 1942, p. 74.

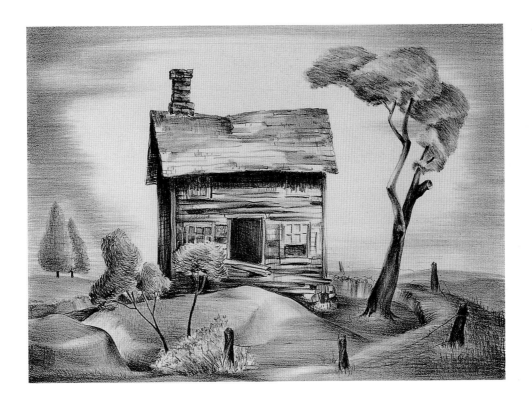

Charles Henry Alston

1907–1977

14. *Deserted House*

ca. 1938
Lithograph
Sheet: 16 x 20⅞ in. (40.6 x 53 cm)
Image: 11⅛ x 15¼ in. (28.3 x 38.7 cm)
Gift of Reba and Dave Williams, 1999
1999.529.1

Born in Charlotte, North Carolina, and raised in New York City, Charles Henry Alston became an influential art teacher and a highly accomplished artist. After graduating from DeWitt Clinton High School in the Bronx, where he served as art editor of the school magazine, Alston received undergraduate and graduate degrees in art from Columbia University. During this time, he offered free art classes to young people at neighborhood centers, including Utopia House and the Harlem Community Art Center. His now-famous art students included Jacob Lawrence, Robert Blackburn, and Romare Bearden (all artists represented in this catalogue).

During the Depression, Alston's large studio at 306 West 141st Street served as a WPA-sponsored art school. Known as 306, it was also a vital gathering place for artists, writers, and other intellectuals and cultural figures. The artists Augusta Savage and Norman Lewis (see cat. no. 19), and the poets and writers Langston Hughes, Claude McKay, and Ralph Ellison, among others, all frequented Alston's uptown studio. As a supervisor of the WPA mural division, Alston was assigned to the Harlem Hospital mural project, to which he also contributed his own work. Alston also experimented with printmaking. As a printer, he was drawn to lithography for its wide tonal range and expressiveness.

Deserted House, with its deteriorating dwelling and abandoned landscape, is an image of despair. The occupants have fled both the house and the land. Created soon after Alston returned from a long investigative journey through the Deep South with a Farm Security Administration (FSA) inspector, the lithograph is most likely based on the sketches and photographs he produced while reexperiencing the former states of the Confederacy. With its fine discriminations of light and shadow, the print evokes a site of both loneliness and desperation and lyrical, haunting beauty.

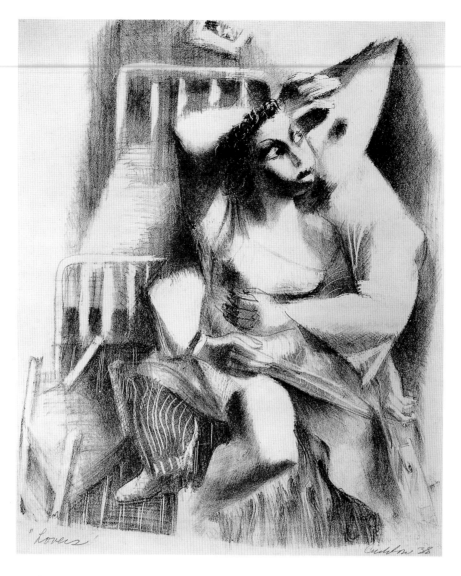

"Lovers" Crichlow 38

Ernest Crichlow

born 1914

15. *Lovers*

1938
Lithograph
Sheet: 15 x 12⅝ in. (38.1 x 32.1 cm)
Image: 14 x 11¾ in. (35.6 x 29.8 cm)
Gift of Reba and Dave Williams, 1999
1999.529.46

In this harrowing bedroom scene by Ernest
Crichlow, a member of the Ku Klux Klan grasps
an African-American woman in a violent embrace. Holding the struggling woman on his lap, the hooded intruder tries to pull up her dress. The broken, overturned chair, the ominous presence of the bed, and the woman's slipped dress strap all suggest that this already brutal scene will also include rape.

The primary goal of the Ku Klux Klan, first organized by veterans of the Confederate Army after the Civil War, was to restore white domination over the newly freed black population during Reconstruction. Dressed in white robes and sheets and using terrorist tactics, such as rape and lynching, the Klan worked to intimidate recently enfranchised African Americans into submission and subordination to white Americans. Largely dormant for several decades after Reconstruction, the KKK resurfaced in 1915.

Crichlow's ironically titled print *Lovers* visually hints at the link between southern violence and the Great Migration north of African Americans between the world wars, as the underlying impetus for this exodus was a desire to escape not only economic exploitation but sexual exploitation as well.

Raised in Brooklyn, Crichlow participated in federally sponsored art programs in both the North and the South. He taught at the Harlem Community Art Center in New York, and he worked for the Greensboro Art Project in North Carolina. This powerful lithograph is his only surviving WPA print.

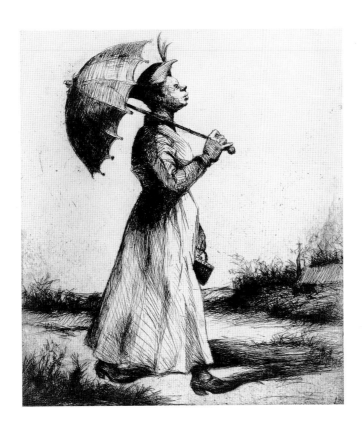

Dox Thrash

1893–1965

16. *Sunday Morning*

ca. 1939
Drypoint
Sheet: 12⅞ x 10¾ in. (32.7 x 27.3 cm)
Image: 8⅞ x 7⅞ in. (22.5 x 20 cm)
Gift of the Works Progress Administration, 1943
43.46.79

Born in rural Georgia, Dox Thrash dropped out of school after the fourth grade, left home at fifteen, and traveled and worked odd jobs for a few years before settling in Chicago. Pursuing his desire to be an artist, he attended classes at the School of the Art Institute of Chicago. And after serving in the military during World War I, he completed art school in 1923. Upon finishing, he lived an itinerant life. Of this eventful time, he wrote:

> After my art education was completed, I was lured back to the open road, hobo-ing, working part [of] the time on odd jobs. Such as, bell boy, dining car waiter, private car porter, massager in bathhouses, black face comedian in carnivals, small town circuses, and vaudevilles. With the idea of observing,

drawing and painting the people of America. Especially the "Negro."[1]

Thrash moved to Philadelphia in 1925. Working as a commercial artist to support himself, he furthered his formal art training, studying printmaking at the Graphic Sketch Club with Earl Horter (1880–1940). Soon after he began exploring the medium, he started to exhibit his work.

From 1937 to 1941, Thrash was employed as head of the WPA's Fine Print Workshop of Philadelphia. Produced at this acclaimed workshop, *Sunday Morning* is a playful representation of a type rather than an individual, perhaps reminiscent of women from the artist's southern upbringing. A prim, prideful woman is shown on her way to church (seen at right in the distance). With upturned nose and head held aloft, the old-fashioned lady wears a feather-adorned hat and sports a gaily tilted parasol in this fanciful vignette. (See also cat. nos. 28, 43.)

1. Dox Thrash, "The History of My Life," typescript, n.d., quoted in "Dox Thrash: 'I Always Wanted To Be an Artist,'" in *Dox Thrash: An African American Master Printmaker Rediscovered*, ed. John W. Ittmann, (exh. cat., Philadelphia: Philadelphia Museum of Art, 2001), p. 5.

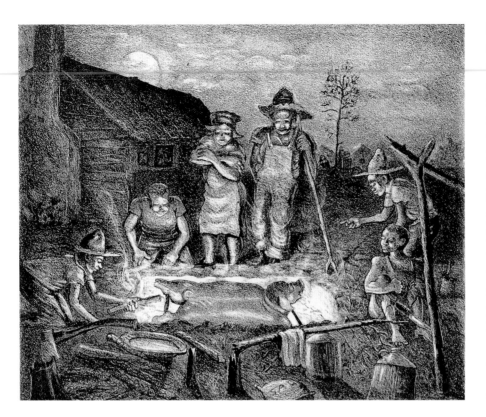

Raymond Steth

1917–1997

17. *Southern Barbecue*

ca. 1940
Lithograph
Sheet: 9 x 11¾ in. (22.9 x 29.8 cm)
Image: 8 x 9¾ in. (20.3 x 24.8 cm)
Gift of Reba and Dave Williams, 1999
1999.529.159

Raymond Steth built a vibrant artistic career based on his active participation in the Fine Print Workshop of Philadelphia. Soon after joining the workshop, in 1938, the young artist realized that printmaking was the ideal medium for him to express his rich memories and visions. Drawing on his rural upbringing and his vivid imagination, Steth, in *Southern Barbecue*, depicts a moonlit hog roast. This festive and quintessentially southern tradition has been dramatically described in a recent publication:

Elaborate preparations began the night before, when men all worked together to dig a huge pit in the ground. Into the pit, they'd lower a whole hog that had been cleaned, spiced and stuffed in the cavity with onions and aromatic vegetables. . . . The hog would roast, smouldering overnight in the earthen oven. The next day, the men would dig the pig out and put it on a spit, where it would keep turning all day. . . . By about two in the afternoon, you could smell the sweet pork for miles around. When the pig was done, we'd stand there with our plates held out, waiting for just the pieces we wanted.[1]

Illuminated by the burning coals of the fire, Steth's nighttime gathering has the aura of a ritual, as, gripped by the sight of the splayed hog set in the open, glowing pit, the eager roasters stand enraptured under the promise of a full moon. (See also cat. nos. 27, 47.)

1. Isaac Hayes, quoted in Bee Wilson, "Summer Sizzlers," *New Statesman* 130 (June 11, 2001), p. 66.

4. The North

Between the world wars, hundreds of thousands of African Americans from southern states migrated to cities in the North seeking a better life. One Chicago newspaper headline put the total number of this Great Migration at half a million.[1] As St. Clair Drake and Horace Cayton summarized in their landmark 1945 study of Chicago, *Black Metropolis: A Study of Negro Life in a Northern City:*

> Prior to 1915 . . . there had been little to encourage plantation laborers to risk life in the city streets. Now there were jobs to attract them. Recruiting agents traveled south, begging Negroes to come north. They sometimes carried free tickets in their pockets, and always glowing promises on their tongues. For the first time, southern Negroes were actually being invited, even urged, to come [north]. They came in droves—50,000 of them [to Chicago] between 1910 and 1920. And as each wave arrived, the migrants wrote the folks back home about the wonderful North. A flood of relatives and friends followed in their wake.[2]

From 1930 to 1940, their numbers increased by more than 43,000 (in Chicago alone), with an additional 60,000 arriving over the next four years.[3]

This tide of southern arrivals aggravated problems that already existed in northern cities—congestion, inadequate housing, inferior recreational and after-school facilities, overcrowded schools, and during the Depression a lack of employment opportunities. Poignant images, such as Norman Wilfred Lewis's of the poor on a soup kitchen line (cat. no. 19) or William E. Smith's solitary man by a lamppost (cat. no. 20), illustrate the suffering that too often awaited black Americans in the northern cities. Claude Clark's protagonist is weighed down by his heavy load and dwarfed by his surroundings (cat. no. 21). And a union organizer holds forth in Wilmer Angier Jennings's densely crowded scene (see cat. no. 23), alluding to the passion incited by labor issues at this time.[4] Others, however, such as Harlem resident Jacob Lawrence (see cat. no. 18) and Boston artist Calvin Burnett (see cat. no. 22), presented more positive views of urban life in the North, filling their pictures with energy and human activity.

LMM

1. The unidentified headline reads: "Half a Million Darkies from Dixie Swarm to the North to Better Themselves." See St. Clair Drake and Horace R. Cayton, *Black Metropolis: A Study of Negro Life in a Northern City,* with an introduction by Richard Wright and a new foreword by William Julius Wilson (1945; rev. ed., Chicago: University of Chicago Press, 1993), p. 61. This groundbreaking study of race and urban life was based on research conducted by WPA fieldworkers in the late 1930s.
2. Ibid., p. 58.
3. Ibid., pp. 88, 90.
4. Interestingly, Jennings, a southern-born and -educated artist, made this northern image when he excised the group of union men from one of his larger, painted compositions, *The Rendezvous,* 1942 (Kenkeleba Gallery, New York), that is clearly set in the South. For a reproduction of this painting, see Claude L. Elliot and Corrine Jennings, *Pressing On: The Graphic Art of Wilmer Jennings* (exh. cat., Providence: Museum of Art, Rhode Island School of Design, 2000), p. 29.

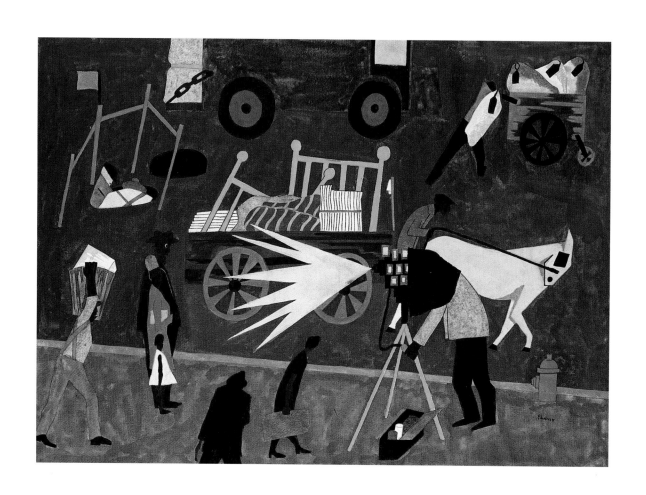

Jacob Lawrence

1917–2000

18. *The Photographer*

1942
Watercolor, gouache, and pencil on paper
22⅛ x 30½ in. (56.2 x 77.5 cm)
Purchase, Lila Acheson Wallace Gift, 2001
2001.205

Born in 1917 in Atlantic City, New Jersey, Jacob Lawrence moved with his mother, brother, and sister to a Manhattan apartment on West 143rd Street in 1930. As a young student in Harlem, he attended neighborhood art classes, and in 1935, at age eighteen, he started painting scenes of his neighborhood, using poster paint and brown paper. The following year, Lawrence began what would become his ritual of doing background research for his art projects at the 135th Street branch of the New York Public Library (now the Schomburg Center for Research in Black Culture). During the late 1930s, he worked for the WPA's Easel Painting

Division. In 1941, Lawrence completed the important series The Migration of the Negro, which brought him wide public recognition and critical acclaim when it was purchased jointly by the Museum of Modern Art, New York, and the Phillips Collection, Washington, D.C. The cycle included sixty tempera paintings illustrating the mass movement of African Americans from the rural South to the urban North between the world wars. His next project, dating from 1942–43, was a series of thirty paintings based on everyday life in Harlem.

The Photographer is one of these paintings. Here, the artist evokes the sights and sounds of a busy street in Harlem filled with vehicles, pedestrians, and workers. A photographer, poised under the black cloth covering his camera, is shown taking a picture of a well-dressed family, who are oblivious to the activity bustling around them. The street is viewed from above, perhaps from the perspective of neighbors looking out of their apartment windows. As viewers, we too are drawn into this vibrant scene of modern city life. (See also cat. nos. 30, 41.)

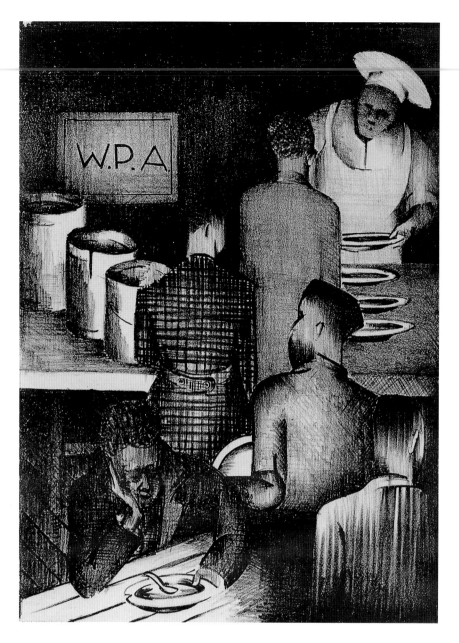

Kitchen is representative of his Depression-era work. From the mid-1930s to the mid-1940s, the artist produced paintings and prints which depict the hardships that African-American city dwellers were subjected to; evictions, poor housing, breadlines, and police brutality are recurrent themes in his art. These works were done in the Social Realist style and are closely aligned with the ideological foundation of Social Realism: that protest art can produce progressive social change.

The subject of this lithograph is the anonymous line of faceless, suited men waiting for a free bowl of soup, their dejection underlined by a somber palette of dark grays. The background wall, while black and forbidding, serves to place in relief the name of the government sponsor—of the meal and of the artist. The repetition of certain elements in the composition—the men, the soup pots, the bowls—suggests the endless, monotonous nature of this dire scene.

Norman Wilfred Lewis

1909–1979

19. *The Soup Kitchen*

ca. 1937
Lithograph
Sheet: 21½ x 17¼ in. (54.6 x 43.8 cm)
Image: 15½ x 11⅛ in. (39.4 x 28.3 cm)
Gift of Reba and Dave Williams, 1999
1999.529.118

Made while Norman Wilfred Lewis was affiliated with the Harlem Community Art Center, *The Soup*

Lewis was an influential activist. During the 1930s, he lobbied for the economic and political rights of artists and other workers. He fought for the establishment of a federally funded art center in Harlem and lobbied to increase the number of African-American artists employed by the WPA. He was also central to the heated discussions at 306 (see cat. no 14). Although Lewis remained a committed activist, he began, in the wake of World War II, to question his earlier belief in the ability of art to effect social change, and in the late 1940s he began to move away from figurative representation toward nonobjective abstraction.

William E. Smith

1913–1997

20. *The Lamppost*

1938
Linocut
Sheet: 13 x 8½ in. (33 x 21.6 cm)
Image: 9½ x 6 in. (24.1 x 15.2 cm)
Gift of Reba and Dave Williams, 1999
1999.529.150

First trained at Cleveland's Playhouse Settlement /
Karamu House during the 1930s, William E. Smith
developed his considerable printmaking skills by
taking home cheap linoleum blocks from the noted
settlement house and cutting into them with hand-
made tools. With his talent and determination,
Smith was able to transform this pivotal opportunity
into a long and productive career as an innovative
printmaker with a unique style.

The Lamppost exemplifies Smith's distinct the-
atrical style and his interest in the theme of the
lone figure. The print's poignant subject matter is
dramatized by boldly cut lines and powerful con-
trasts between black and white. Like an actor on a
stage set, a teenage boy leans casually against a
lamppost bathed in warm light, contemplating the
dark night that surrounds him. Somber and emo-
tionally charged, the print evokes both the drama
and the loneliness of modern life. The poet Langston
Hughes, who was also highly attentive to the
drama of modern living, exclaimed that through
his use of "line and color," Smith graphically cap-
tured "the humor and . . . pathos of Negro life."[1]

1. Quoted in *Alone in a Crowd: Prints of the 1930s–40s
by African-American Artists, from the Collection of
Reba and Dave Williams* (exh. cat., [New York]:
American Federation of Arts, 1993), p. 55.

Claude Clark

1915–2001

21. *Philadelphia Alley*

1940
Lithograph
Sheet: 16 x 11⅜ in. (40.6 x 28.9 cm)
Image: 11⅞ x 9¼ in. (30.2 x 23.5 cm)
Gift of Reba and Dave Williams, 1999
1999.529.38

After graduating from the Pennsylvania Museum and School of Industrial Art (now the University of the Arts), Claude Clark, from 1939 to 1944, was under the tutelage of the renowned collector Albert C. Barnes (1872–1951). Dr. Barnes collected both modern European and traditional African art, and as a student at the Barnes Foundation, in Merion, Pennsylvania, the young artist had access to his extensive collection. (Barnes would later purchase one of Clark's paintings.) From 1939 to 1942, Clark also worked at the Fine Print Workshop of Philadelphia, where he shared a studio with Raymond Steth and studied with Dox Thrash, experimenting with Thrash's carborundum technique (see pp. 87–88). Clark was particularly inspired by the subject matter of Thrash's innovative prints: "I was attracted to . . . [Thrash's] work because I too was born in rural South Georgia. I liked the genre quality of his work, and even in Philadelphia . . . that was always in his subject matter—the folk quality."[1]

In addition to focusing, like Thrash's work, on everyday life, Clark's *Philadelphia Alley* also serves as subtle social commentary. Dwarfed by the buildings that surround him, a black man strains to haul a load of garbage through a dilapidated urban alley. It is the man's plight, rather than the individual, that is the focus of this scene, which quietly but forcefully alludes to the inequities of life in the city.

1. Quoted in David R. Brigham, "Bridging Identities: Dox Thrash as African American and Artist," *Smithsonian Studies in American Art* 4, no. 2 (Spring 1990), p. 33.

Calvin Burnett

born 1921

22. *Tavern*

1942
Linocut
Sheet: 6 x 8¼ in. (15.2 x 21 cm)
Image: 5 x 7 in. (12.7 x 17.8 cm)
Gift of Reba and Dave Williams, 1999
1999.529.22

Fresh out of art school, Calvin Burnett went to work at the busy wartime Boston Navy Yard in July 1942 and two months later was drafted into military service. Disqualified because of poor eyesight, he returned to the dry dock and worked there until the war's end. Although some artists tried to use their creative skills at their home-front jobs, Burnett decided not to seek an art-related position, such as that of draftsman. Instead, he joined a crew that serviced military ships. Concerning this decision, he later remarked, "I knew at the time that I did not want to be a draftsman. . . . It seemed like anti-art. I was still an artist, you know, and still thinking of myself *only* as an artist. And I carried that

into my bilge cleaning and tank cleaning. I was assigned to the riggers' shop as a laborer."[1]

While employed at the navy yard, Burnett made a series of sketches based on daily wartime life, as well as work that treated everyday civilian life. *Tavern*, a linocut based on a working sketch, shows two anonymous men huddled under the tilted sign of a neighborhood bar. It is raining, and people pass by with open umbrellas, including a quite sizable one seen in the lower left. The windswept rain falls directly on the dejected men, who wait out the downpour in front of Joe's Tavern, the local watering hole. Produced in a very small edition of two or three, and used in printmaking demonstrations for his students at the Massachusetts College of Art, this expressive print captures one wet corner of wartime street life in the North. (See also cat. nos. 44a, b.)

1. Calvin Burnett, transcript of interview by Robert Brown, June 13, 1980, tape 1, side b. Oral History Interviews, Archives of American Art, Smithsonian Institution, Washington, D.C.: available online.

Wilmer Angier Jennings

1910–1990

23. *Harangue*

1942
Wood engraving
Sheet: 13 x 10 in. (33 x 25.4 cm)
Image: 7⅞ x 6 in. (20 x 15.2 cm)
Gift of Reba and Dave Williams, 1999
1999.529.70

Wilmer Angier Jennings studied at the Rhode Island School of Design, in Providence, from 1935 to 1938 and worked for the Graphic Arts Division of the Rhode Island WPA. A number of his prints were featured in "Contemporary Negro Art," held at the Baltimore Museum of Art in 1939, the first exhibition of the work of African-American artists at a major museum. Jennings was also selected to represent the state of Rhode Island at the World's Fair, held in New York in 1939. In 1940, he participated in the exhibition "The Art of the American Negro (1851–1940)," organized by the Tanner Art Galleries in Chicago.

Jennings explored a wide range of subjects in his work, including landscapes, seascapes, still lifes, portraiture, and rural and urban genre scenes. His wood engravings are notable for their painterly treatment of light. *Harangue*, a work dating from 1942, shows his command of chiaroscuro. A union organizer in a dark suit and bathed in soft light gives a rousing lecture to six men who are portrayed within a broad spectrum of light and dark. Each of the men has a different response to the activist's fiery speech. Some listen intently, while others hang back; the man in the foreground, uninterested in the soapbox harangue, calmly lights a cigarette.

Corrine Jennings, the artist's daughter, remembers her father making many of his own carving tools and "fashioning them according to the lines or textures he wanted to see in his prints."[1] Here, Jennings combines expressive forms, a wide range of tones, and technical precision to creatively link form and content. (See also cat. no. 3.)

1. Corrine Jennings, "Wilmer Jennings: A Remembrance," in *An American Legacy: African American Printmakers* (exh. cat., Allentown, Pa.: Tompkins Gallery, Cedar Crest College, 2002), unpag.

5. Religion

African Americans have historically maintained a strong connection to religious institutions. Churches large and small, from cathedrals to storefronts—Catholic, Episcopal, Methodist, Baptist, and Pentecostal—have flourished in African-American communities, becoming centers not only of religious life but of social commitment and political activism. During the Depression, churches offered both emotional solace and spiritual guidance and provided soup kitchens and shelters. Charismatic leaders, such as Bishop Charles Manuel "Sweet Daddy" Grace (ca. 1881–1960) and George Baker (1877–1965), known as Father Divine (whose soup kitchens were called "heavens"), drew large followings in Harlem and in Philadelphia and other urban areas. Recording the important presence of religion in the daily lives of African Americans were photographers such as James VanDerZee (1886–1983), who worked in Harlem in the 1920s and 1930s, and Gordon Parks (b. 1912), one of the government-sponsored photographers of the 1930s and 1940s employed by the Farm Security Administration (FSA).

Painters and printmakers of this era also addressed the issue of religion as it affected African Americans. Romare Bearden and Allan Rohan Crite (see cat. nos. 24, 25a, b) selected images from established religious doctrine—the Passion of Christ, for example—that suggested corollaries to contemporary African-American life (e.g., persecution and lynching). Crite's interpretation of these figures as black may have been influenced by Marcus Garvey's "new theocracy for the African Orthodox Church, complete with a Black God, a Black Jesus, a Black Madonna, and Black Angels."[1] Garvey (1887–1940), the promoter of Pan-Africanism in the late 1910s and 1920s (see p. 19), encouraged African Americans to see religious figures through "their own spectacles."[2] This idea was taken up by artists and writers of the Harlem Renaissance such as Countee Cullen (1903–1946), who wrote *The Black Christ and Other Poems* (1929), and Aaron Douglas (1899–1979), who made several illustrations in the mid- to late 1920s that interpret traditional religious iconography with black protagonists.[3]

Other artists presented in this section chose everyday subjects that assumed spiritual significance by virtue of their associations to established religious imagery. Robert Blackburn's boating scene (cat. no. 26), for example, would seem to have been partly inspired by Raphael's famous cartoon for the tapestry of the biblical story of the Miraculous Draught of Fishes,[4] while Elizabeth Catlett's mother embracing her infant (cat. no. 29) assumes the pose of a traditional Madonna and child. Like the FSA photographers, Raymond Steth and Dox Thrash (see cat. nos. 27, 28) both treated religious themes and documented religious practices in the South.

LMM

1. Jane Seney in Dewey F. Mosby, ed., *Life Impressions: 20th-Century African American Prints from The Metropolitan Museum of Art* (exh. cat., Hamilton, N.Y.: Picker Art Gallery, Colgate University, 2001), p. 22.
2. Amy Jacques-Garvey, ed., *Philosophy and Opinions of Marcus Garvey* (New York: Arno Press, 1968), vol. 1, p. 44, quoted in Mosby, *Life Impressions*, p. 22.
3. See, for example, Aaron Douglas, "I Couldn't Hear Nobody Pray," *Opportunity*, November 1925, where God and man have black features, and several illustrations in Alain Locke's book *The New Negro: An Interpretation* (New York: Boni, 1925), including views of a black Adam and Eve and a black Eve in an African Garden of Eden.
4. Blackburn knew the Raphael cartoon, but says that the inspiration for this work derives from the plight of blacks in the South. Interview with the author, September 17, 2002.

Romare Bearden

1911–1988

24. *Golgotha*

1945
Watercolor, pen and India ink, and pencil on paper
19⅞ x 25½ in. (50.5 x 64.8 cm)
Bequest of Margaret Seligman Lewisohn, in memory
of her husband, Sam A. Lewisohn, 1954
54.143.9

Known primarily for his earthy and exuberant collages, Romare Bearden was also gifted at working with watercolor. *Golgotha* is part of The Passion of Christ series, dating from 1945. Exhibited in October of that year, in Bearden's first New York gallery show (at the Samuel Kootz Gallery), shortly after the artist had been discharged from the army, this series of watercolors and oils was widely praised and eagerly acquired. In his glowing review of the exhibition, which appeared in the October 1945 edition of *Art Digest*, the art critic Ben Wolf wrote that Bearden "wrestles with angels [and is] one of the most exciting creative artists I have viewed for a very long time."[1] Works from this series were immediately purchased by the legendary jazz musician Duke Ellington (1899–1974) and by the Museum of Modern Art, New York. Bearden's reputation continued to skyrocket throughout his lengthy and successful career, making him one of the most recognized and respected African-American artists of the twentieth century.

Golgotha is titled after the site of the Crucifixion, on the outskirts of the ancient city of Jerusalem. Bearden's choice of subject, the anguish of Christ on the cross, while it may allude to the horrors of World War II, also offers the possibility of redemption. The strong lines, sharp angles, fragmented spaces, and abstracted figures of this powerful work all serve to enhance the visceral nature of this tragically human subject.

1. Ben Wolf, "Bearden—He Wrestles with Angels," *Art Digest* 20 (October 1, 1945), p. 16.

Allan Rohan Crite
born 1910

25a. *African-American Madonna*
Linocut
1937
Sheet: 7 x 3¾ in. (17.8 x 9.5 cm)
Image: 4⅞ x 2⅞ in. (12.4 x 7.3 cm)
Gift of Reba and Dave Williams, 1999
1999.529.48c

25b. *Jesus Is Nailed to the Cross*
Linocut
1937
Sheet: 10¾ x 7½ in. (27.3 x 19.1 cm)
Image: 5 x 2⅞ in. (12.7 x 7.3 cm)
Gift of Reba and Dave Williams, 1999
1999.529.48d

Allan Rohan Crite's interest in representing the Christian story began when he was a child and has been a major focus of his work for over six decades. Regarding the continuous presence of religion in his work, Crite has declared: "I've done one piece of work in my life. I started when I was six and it continues."[1]

Crite's religious figures are usually portrayed as black, as they are in the series The Life of Christ, to which both *African-American Madonna* and *Jesus Is Nailed to the Cross* belong:

> I used the black figure in a telling of the story of the Lord, the story of the suffering of the Cross and the whole story of the Redemption of Man by the Lord, but here, my use of the black figure was not in a limited racial sense, even though I am black, but rather I was telling the story of all mankind through this black figure.[2]

Creating art for religious rituals is one way Crite has linked his art and his faith. Throughout his lengthy career, he has completed several series of ecclesiastical narrations of the Passion.[3] The liturgical images in The Life of Christ illustrate the fourteen Stations of the Cross, images that enable churchgoers to journey symbolically with Christ to Golgotha. Perhaps intended for the eleventh station, Crite's tightly composed image of a haloed Christ being nailed to the cross starkly illustrates a pivotal incident in the life of Christ and encourages believers to contemplate his crucifixion and ultimate resurrection.

1. Quoted in Barbara Earl Thomas, "Allan Rohan Crite: Ordinary Miracles," in *Allan Rohan Crite: Artist-Reporter of the African-American Community*, ed. Julie Levin Caro (exh. cat., Seattle: Frye Art Museum, 2001), p. 11.
2. Quoted in Edmund Barry Gaither, "Allan Rohan Crite: An American Original," in *Allan Rohan Crite: Artist-Reporter*, p. 20.
3. Edward Clark, "Annamae Palmer Crite and Allan Rohan Crite: Mother and Artist Son—An Interview," *Melus* 6, no. 4 (Winter 1979), pp. 73–74.

Robert Blackburn

born 1920

26. *People in a Boat*

ca. 1937–39
Lithograph
Sheet: 15¼ x 19¾ in. (38.7 x 50.2 cm)
Image: 11⅛ x 15¾ in. (28.3 x 40.3 cm)
Gift of Reba and Dave Williams, 1999
1999.529.9

In 1992, at age seventy-two, Robert Blackburn
was awarded the prestigious MacArthur Foundation
Fellowship for his outstanding contribution to the
field of printmaking. The masterly print *People
in a Boat* was executed at the start of Blackburn's
career, when he was still a teenager. Made at the
WPA-sponsored Harlem Community Art Center,
it is typical of Depression-era work in its depiction
of the lives of working people and the plight of
African Americans in the South.

Unlike much socially conscious art produced
during the Depression, however, *People in a Boat*
alludes to sacred subject matter. The print illus-
trates the biblical story of the Miraculous Draught
of Fishes (Luke 5:1–11 and John 21:1–8), in which
Christ performs a miracle by enabling his disci-
ple Peter and Peter's companions to handily net
a school of fish. Astonished by the bounty of their
catch, the previously hungry and wary fishermen
become fully convinced of Christ's divine powers.

For Blackburn, this powerful image found a
corollary with the desperation of African Americans
in the South, who sought escape from persecution
and poverty. Although the artist himself had never
been there, he was well aware of the conditions to
which blacks in the South were subjected. (See
also cat. no. 39.)

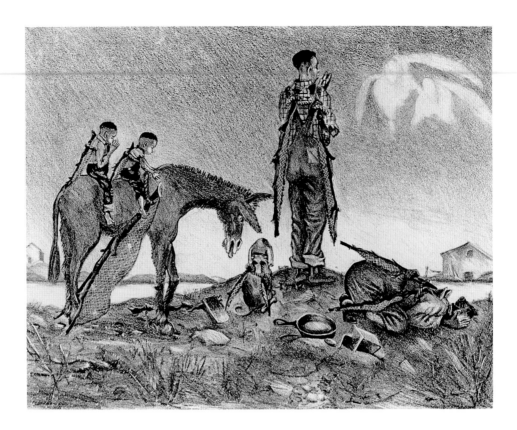

Raymond Steth

1917–1997

27. *Heaven on a Mule*

ca. 1938–43
Lithograph
Sheet: 11 x 14⅛ in. (27.9 x 35.9 cm)
Image: 8¾ x 11⅛ in. (22.2 x 28.3 cm)
Gift of Reba and Dave Williams, 1999
1999.529.155

Heaven on a Mule is a visual representation of profound faith. It tells the story of a destitute family in search of deliverance. In this deeply religious scene, a family of four and their dog and mule are alone in their thoughts, poised for a communal trip to heaven. Wearing homemade wings, they await their sacred journey amid their few earthly possessions. Each family member, including the dog and the mule, anticipates his (or her) entrance into heaven in his own personal way. Palms pressed together in prayer, the man stands atop a mound of sparse earth. The woman, on her knees, tightly covers her eyes and presses her head to the ground.

Mounted on the mule, the two small boys bow their heads in silence. Similarly, the dog mimics his master's stance, while the mule bends his head in the manner of the boys who ride him.

Made while Raymond Steth was working at the Fine Print Workshop of Philadelphia, the lithograph was likely inspired by his strong connections to the rural South. He described the religiosity of the subjects:

> The people are so devout that religion is first and foremost in their lives. They did everything they could according to the Bible. The family was ready to go to Heaven, bringing all their earthly belongings, and wearing wings they had made. The woman had read in the Bible that the Lord is so beautiful that you can't look him in the face. The man is so fervent that he thought he saw the angels.[1]

(See also cat. nos. 17, 47.)

1. Quoted in *Alone in a Crowd: Prints of the 1930s–40s by African-American Artists, from the Collection of Reba and Dave Williams* (exh. cat., [New York]: American Federation of Arts, 1993), p. 1.

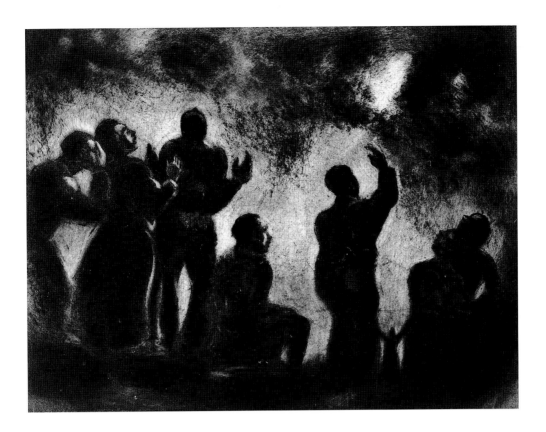

Dox Thrash

1893–1965

28. *Glory Be*

ca. 1938–42
Carborundum mezzotint, aquatint, and etching
Sheet: 9 x 11⅜ in. (22.9 x 28.9 cm)
Plate: 7⅜ x 9⅞ in. (18.7 x 25.1 cm)
Gift of Reba and Dave Williams, 1999
1999.529.162

In the late 1930s, with the help of his WPA col-
leagues, Dox Thrash pioneered a technique of
intaglio printmaking at the Fine Print Workshop of
Philadelphia. Now known as the carborundum print
process, the technique—a variant of mezzotint—
saves time and effort and creates prints with rich
tonal variations.[1]

The process involves using gritty silica crystals,
known by the brand name Carborundum, to
abrade the surface of the metal plate used to pro-
duce the print. The crystals create a pitted surface
that enables the metal plate to hold ink. After the
plate has been abraded, an image is scraped into
the surface. This results in areas of black where the

ink-filled pitted surface is left intact, areas of gray
where the surface is moderately altered, and areas
of white—the white of the paper—where no ink
has adhered. Variations in tone are achieved by
applying different grades of silica crystals to the
metal plate. (See also pp. 87–88.)

In *Glory Be*, rich gradations of dark and light
serve to dramatize the religious scene. Silhouetted
against the night sky, a small gathering of men and
women witness the brilliant light of God breaking
through the clouds. Although united in seeing this
blazing vision, each person responds individually,
as their body language suggests. Some sit, some
stand, some raise their arms upward or cover their
face. The presence of one small figure in the dis-
tance, at the horizon line, suggests that the seven
figures in the foreground may be part of a larger cir-
cle of worshipers. The print's soft hues and velvety
tones enhance the intimate religiosity of the sub-
ject. (See also cat. nos. 16, 43.)

1. Cindy Medley-Buckner, "The Fine Print Workshop of
 the Philadelphia Federal Art Project," in *Dox Thrash:
 An African American Master Printmaker Rediscovered*,
 ed. John W. Ittmann (exh. cat., Philadelphia:
 Philadelphia Museum of Art, 2001), p. 48.

Elizabeth Catlett

born 1919

29. *Mother and Child*

1944
Lithograph
Sheet: 12⅜ x 9⅜ in. (31.4 x 23.8 cm)
Image: 7¾ x 5¾ in. (19.7 x 14.6 cm)
Gift of Reba and Dave Williams, 1999
1999.529.34

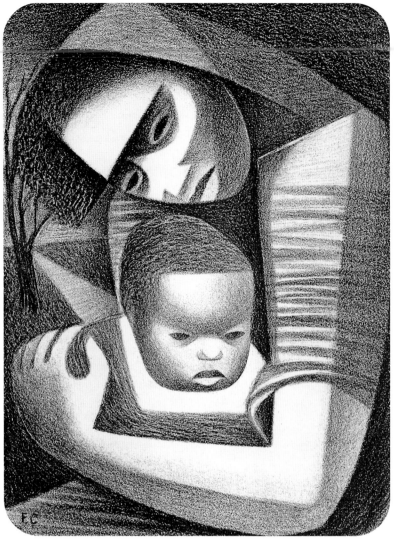

Elizabeth Catlett, while known primarily as a sculptor, is also a prolific printmaker. The theme of the mother and child has been central to her work. A limestone sculpture titled *Negro Mother and Child*, completed in 1940 (location unknown), was the work for which she was awarded first prize for sculpture at the exhibition "The Art of the American Negro (1851–1940)," held in Chicago the same year. Accompanying the sculpture was Catlett's written statement:

> To create a composition of two figures, one smaller than the other, so interlaced as to be expressive of maternity, and so compact as to be suitable to stone, seemed quite a desirable problem. The implications of motherhood, especially Negro motherhood, are quite important to me, as I am a Negro as well as a woman.[1]

With its simplified forms, entwined figures, sense of volume, and expressive power, the lithograph *Mother and Child* echoes its sculptural predecessor. Drawing on the iconography of early Christian art and infused with a modern visual vocabulary, the abstracted maternal figure is based on Cubist-inspired shapes, whereas the child is rendered more naturalistically. The protective tenderness of the image contrasts with the bleak pessimism of *Hope for the Future* (cat. no. 5), a print with a similar theme made a year later by Catlett's then husband, Charles Wilbert White. Intimately encircling her child, the black mother in Catlett's work figuratively sustains the next generation.

1. Elizabeth Catlett, "Introduction to Sculpture in Stone: *Negro Mother and Child*" (M.F.A. thesis, University of Iowa, 1940), p. 1, quoted in Melanie Anne Herzog, *Elizabeth Catlett: An American Artist in Mexico* (Seattle: University of Washington Press, 2000), p. 21.

6. Labor

In 1932, the year Franklin D. Roosevelt was elected president, he promised Americans "a new deal" that would give them financial security from "the cradle to the grave." Much of that security was based on providing government-sponsored employment. It was through programs such as the Works Progress/Work Projects Administration (WPA) that large numbers of people in the arts—artists, writers, performers—many of whom had been struggling to survive, were given the opportunity to enter the mainstream and become active participants in American society. Equality without racial discrimination under these government programs, however, was not always achieved. African Americans were generally hired for jobs after white candidates, given lower salaries, and assigned positions beneath their skills and training.

The majority of artists included in this publication were associated with various New Deal projects at some time during their careers (either as students or as paid professionals), and many of the works illustrated here were made under the auspices of the WPA. Given the country's economic crisis and high unemployment, it is not surprising that the theme of Americans at work was a frequent one in the art and photography of the Depression. As the pictures throughout this catalogue indicate, the theme was interpreted to cover the wide range of jobs and skills available to African Americans—from the manual laborers and semiskilled workers on construction sites (cat. nos. 31, 34, 35) and in defense jobs (cat. nos. 43, 44a, 46) to local tradesmen (cat. nos. 30, 32) and even to the artists themselves (cat. no. 8). The importance of labor unions at this time—many of which reached out to African Americans and voiced the need for racial equality—underlies Wilmer Jenning's print *Harangue* (cat. no. 23) and is seen as the backdrop to Hughie Lee-Smith's cinematic view of the artist's life (cat. no. 33).

LMM

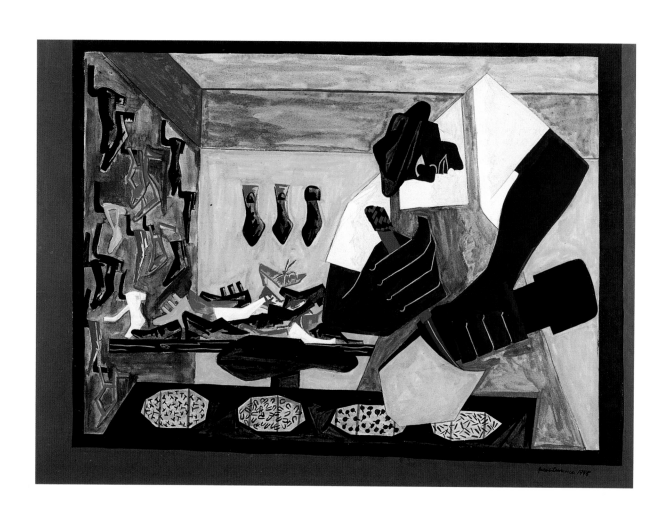

Jacob Lawrence

1917–2000

30. *The Shoemaker*

1945
Watercolor and gouache on paper
22¾ x 31 in. (57.8 x 78.7 cm)
George A. Hearn Fund, 1946
46.73.2

With its primary colors, geometric shapes, and simplified forms, *The Shoemaker* is a vivid illustration of Jacob Lawrence's signature style, which brought him a devoted following among art enthusiasts throughout his celebrated sixty-year career. Made in 1945, just after he returned to New York City following two years' service in the U.S. Coast Guard, the painting exemplifies the beginning of Lawrence's lifelong interest in representing work and workers, particularly the manual labor of African Americans. It was a subject he would return to frequently until his death in 2000.

Manual labor is dramatized in this picture of a shoemaker in his shop. The cobbler's strength and sense of purpose are reflected in his deep concentration, broad shoulders, and oversize hands. He is himself of heroic proportions and would not be able to stand upright in his small space. In contrast to the powerful presence of the shoemaker are the objects over which he is laboring—the women's high-heeled shoes that gaily adorn the walls.

Throughout his career, Lawrence also made reference to labor in the depiction of workers' tools, which are represented not only for their symbolic value but also for their structural elegance: "It's a beautiful instrument, the tool, especially the hand-tool. We pick it up and it's so perfect, it's so ideal, it's so utilitarian, so aesthetic, that we turn it, we look at it. . . . I always think of the tool as an extension of the hand."[1] (See also cat. nos. 18, 41.)

1. Quoted in Patricia Hills and Peter T. Nesbett, *Jacob Lawrence: Thirty Years of Prints (1963–1993): A Catalogue Raisonné* (exh. cat., Seattle: Francine Seders Gallery in association with the University of Washington Press, 1994), p. 36.

James Lesesne Wells
1902–1993

31. *Builders*
1929
Linocut
Sheet: 19⅞ x 16¼ in. (50.5 x 41.3 cm)
Image: 14 x 10¾ in. (35.6 x 27.3 cm)
Gift of Reba and Dave Williams, 1999
1999.529.173

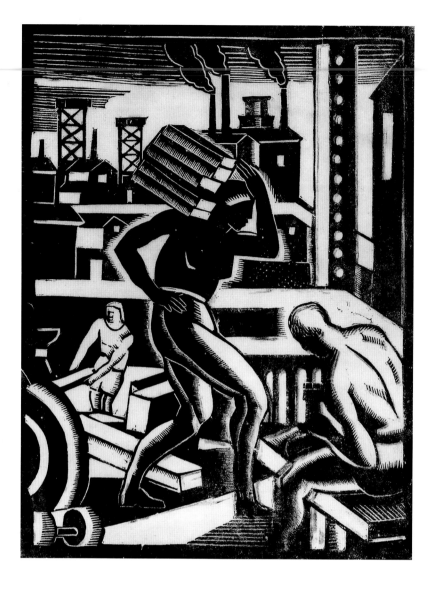

James Lesesne Wells got his start as an artist at the age of nine, when he helped his father, the pastor of a Baptist church in Palatka, Florida, stencil designs on the walls of the church. As a teenager, he won prizes for his artwork at the Florida State Fair, and in 1919, as a young adult, he moved to New York City to pursue a career in the visual arts. In New York, he attended classes at the National Academy of Design and studied printmaking at Columbia University's Teachers College.

The 135th Street Harlem branch of the New York Public Library (now the Schomburg Center for Research in Black Culture), the epicenter of the New Negro movement of the 1920s, sponsored Wells's first exhibition in 1921. Soon after, the most influential voices of the Harlem Renaissance, the NAACP's *The Crisis* magazine and the National Urban League's *Opportunity* magazine, commissioned prints by the emerging artist to accompany their impassioned writings.

With its fusion of an urban subject matter and a modern aesthetic, *Builders* captures the tenor of the Harlem Renaissance. During the New Negro movement, African-American artists were encouraged to develop modern vocabularies with which to address black life. Wells's response to this mandate shows the influence of both the graphic woodcuts of the German Expressionists and the stylized, seminude, profiled figures of ancient Egyptian art. Rendered in strong lines, simplified forms, geometric shapes, and stark contrasts between black and white, Wells's picture celebrates the building of the modern industrial city.

The year this print was made, Wells joined the faculty of Howard University, in Washington, D.C. He taught printmaking there until his retirement in 1968. (See also cat. no. 35.)

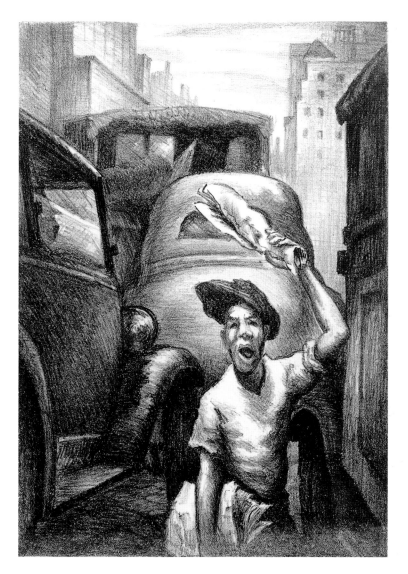

Carl G. Hill

ca. 1920 – ca. 1943

32. *Newsboy*
1938
Lithograph
Sheet: 13⅞ x 10⅝ in. (35.2 x 27 cm)
Image: 11½ x 8⅛ in. (29.2 x 20.6 cm)
Gift of Reba and Dave Williams, 1999
1999.529.65

In the midst of a traffic jam, a young boy makes his way through the congested streets, hawking the daily news. The scene is defined by dramatic contrasts. The boy is small, scrappy, and mobile; the cars are big, fancy, and stalled. The boy is surrounded by a crowding darkness, while far above him the sky is open and light. In the lithograph, Carl G. Hill makes full use of the medium's versatility, using a wide range of tones from blacks and whites to variously shaded grays.

Made in 1938 while he was a student at the Harlem Community Art Center, this print was given by Hill to his mentor, Riva Helfond. Soon after this exchange, he joined the U.S. Merchant Marines. In 1942, there was a call for art made by men and women serving in the armed forces and Hill submitted *Newsboy*. The print was included in the United Seamen's Service Exhibition, held at the Hall of Art in New York City in February 1943. This exhibition, of over one hundred fifty prints, paintings, drawings, and sculpture, was the first public showing of visual art made by merchant marines. The public was astonished by the creativity of the wartime seafarers and eager for more. The popular exhibition had a second showing when it opened at the Corcoran Gallery in Washington, D.C., on November 23, 1943. There, Hill's print was placed in the memorial section because, tragically, the talented artist and marine, only in his twenties, had recently died at sea.[1]

1. Aimée Crane, ed., *Art in the Armed Forces* (New York: Hyperion Press, 1944), p. 227.

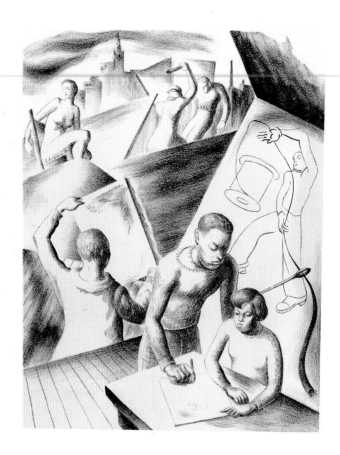

Hughie Lee-Smith

1915–1999

33. *Artist's Life, no. 1*

1939
Lithograph
Sheet: 13 x 10 in. (33 x 25.4 cm)
Image: 11 x 8½ in. (27.9 x 21.6 cm)
Gift of Reba and Dave Williams, 1999
1999.529.112

Hughie Lee-Smith was actively involved in art from his early years. Looking back over his long life, he wrote: "I drew all the time, and it became a natural thing. I breathed it; I dreamed it. Art was my whole being, and I knew from an early age that it was my mission."[1]

During the late 1930s, Lee-Smith earned a degree from the Cleveland School of Art (now the Cleveland Institute of Art), taught at the Playhouse Settlement/ Karamu House, and was employed by the WPA in Cleveland. As a printmaker for the Ohio WPA, he produced a series of lithographs that included *Artist's Life, no. 1*. Influenced by Social Realism, this print grapples with the artist's role in society through its juxtaposition of competing scenarios. In the foreground is a self-portrait of the artist as a teacher, guiding his aspiring student. Behind them a manual worker wields a giant needle and spool of thread. On the left, a painter works from a nude model, and in the background a policeman beats a union demonstrator with a club. These pairings allude to one of the central questions of the day, namely, Should artists work in their studios, developing their individual skills? Or should they be out in the streets, actively working to improve society? This provocative print offers no easy answers.

1. Quoted in Carol Wald, "The Metaphysical World of Hughie Lee-Smith," *American Artist* 42 (October 1978), p. 53.

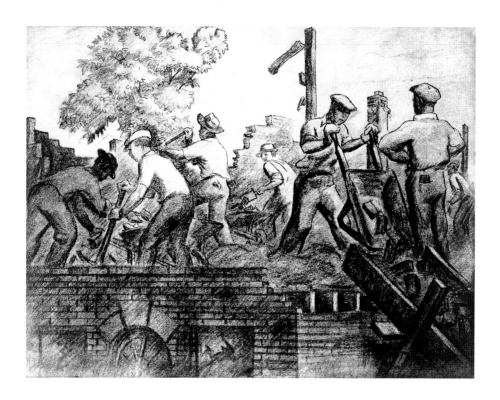

Charles L. Sallée Jr.

1913–1988

34. *Wrecking Crew*

ca. 1940
Soft-ground etching
Sheet: 9¼ x 12 in. (23.5 x 30.5 cm)
Plate: 9 x 11¾ in. (22.9 x 29.8 cm)
Gift of Reba and Dave Williams, 1999
1999.529.140

Like Elmer W. Brown, William E. Smith, and Hughie Lee-Smith (see cat. nos. 11, 20, 33), Charles Sallée was part of a group of artists based at the Playhouse Settlement/Karamu House in Cleveland. After graduating in 1938 from Case Western Reserve University, Sallée was employed as an art teacher at the dynamic neighborhood arts center. During the war years, he was also a printmaker and muralist for the Cleveland WPA. As a college student, as a teacher, and as a participant in the Federal Art Project (FAP), Sallée had the opportunity to work in truly integrated settings, experiences that are reflected in much of his art.

Interracial collaboration is one of the themes in the etching *Wrecking Crew*. A group of white and black laborers at a demolition site are shown in the process of tearing down the top floor of an old brick building. The laborers, most likely white immigrants and black migrants and their sons, work together in harmony, without any visible signs of the racial antagonism that frequently characterized the workforce during the prewar years.

Because of its optimistic tone and naturalistic style, *Wrecking Crew* can be considered an example of American Regionalism. In a manner similar to that of Thomas Hart Benton (see fig. 1 on p. 13) and Grant Wood, Sallée drew inspiration for his art from the American Midwest. Like the work of Benton and Wood, Sallée's art suggests the quiet heroism and dignity of hardworking laborers in America's heartland.

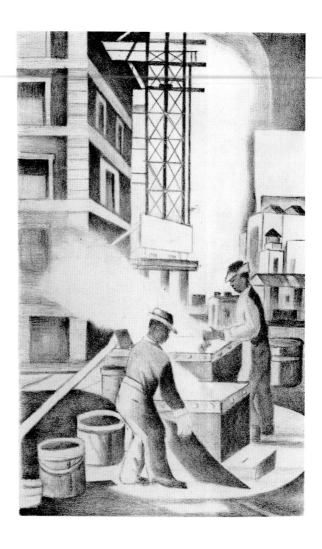

James Lesesne Wells

1902–1993

35. *Asphalt Workers*

1940
Lithograph
Sheet: 14¼ x 9 in. (36.2 x 22.9 cm)
Image: 13⅝ x 8¼ in. (34.6 x 21 cm)
Gift of Reba and Dave Williams, 1999
1999.529.176

Produced eleven years after *Builders* (cat. no. 31), *Asphalt Workers* illustrates the development of James Lesesne Wells's artistic style during the 1930s in response to the austerity of the new era. The hardships of the Depression dramatically called into question the playful exuberance, lavish consumption, decorative decadence, and buoyant optimism that characterized the Jazz Age of the 1920s.

During the 1930s and 1940s, many visual artists moved away from experimenting with modernism, turning instead to a reinvigoration of Social Realism, a style and movement that typically focuses on working people and the struggles of their everyday lives. In stark contrast to Wells's earlier print, *Asphalt Workers* portrays naturalistically the builders of the industrial city performing their tasks with grim determination. The protective clothing that they wear is rendered with accuracy and precision.

Corresponding to Wells's dramatic shift in style from modernism to Social Realism, the artist also changed media, from linocut to lithography. This shift allowed him to more fully visualize the tenets of Social Realism, as lithography creates more naturalistic shading and detail (see p. 89). Composed with close attention to the specific, this sober print honors the quiet heroism of African-American workers laboring to secure a living in difficult times. (See also cat. no. 31.)

7. Recreation

During the Roaring Twenties, also known as the Jazz Age, African-American entertainers gained unprecedented popularity with black and white audiences alike, both at home and in Europe. (Josephine Baker, for example, was a sensation in Paris.) Deemed exotic and lauded as "modern primitives" because their music and dance often drew on the rhythms and movements of African cultures, these performers were seen as the "antidote to what was perceived to be the sterility of modern, technology-dominated Western . . . society."[1] It was a period, noted the poet Langston Hughes, "when the Negro was in vogue."[2]

Throughout the first four decades of the twentieth century, African Americans made major contributions to the performing arts. Among their innovations in music and dance, jazz, blues, ragtime, swing, the jitterbug, and the Lindy Hop were all genres that impacted on the development of American pop culture. Music halls, nightclubs, theaters, and cinemas thrived during the Depression, as Americans sought to escape from the dreariness and hardship of their daily lives (see cat. no. 38). Despite ongoing segregationist practices, Harlem became a mecca for people from all over New York City, who were drawn to its vibrant musical scene.

Ironically, the praise and recognition that these professional entertainers garnered also fed into existing stereotypes about the general musical and dancing abilities of all African Americans. Albert A. Smith's southern scene of dancing children accompanied by a man playing a banjo (cat. no. 37) exposes many of these offensive clichés.

Out of the spotlight, average African Americans also found other places where they could socialize and relax. Bars and clubs—Calvin Burnett's Boston-area tavern, Palmer Hayden's Paris café, and the Harlem sites of Robert Blackburn and Jacob Lawrence (cat. nos. 22, 36, 39, 41)—provided meeting places for friends to play cards, shoot pool, or pick up a game of checkers. Against the backdrop of Washington Square Park, Joseph Delaney paints a racially mixed crowd of New Yorkers enjoying a summer's day (cat no. 40).

LMM

1. Sharon F. Patton, *African-American Art* (Oxford: Oxford University Press, 1998), p. 111.
2. Hughes (1926) quoted in ibid.

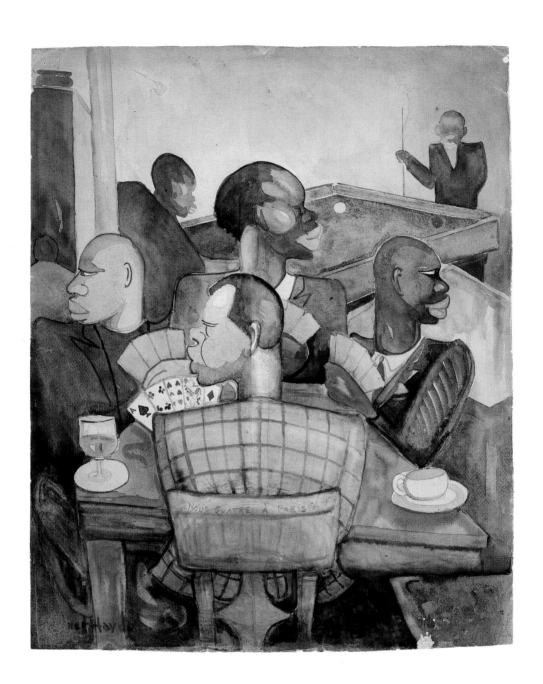

Palmer Hayden

1890–1973

36. *Nous Quatre à Paris*

ca. 1930
Watercolor and pencil on paper
21¾ x 18⅛ in. (55.2 x 46 cm)
Purchase, Joseph H. Hazen Foundation Inc. Gift, 1975
1975.125

Paris was a favorite destination for African-American artists, musicians, and writers in the 1920s. Artists who had the means to travel across the Atlantic flocked to the City of Light during the Jazz Age.

Palmer Hayden's *Nous Quatre à Paris* (We Four in Paris) most likely depicts the artist and three of his African-American and Caribbean-American friends playing cards in the back room of a Paris café. Four black men in stylish suits are shown seated around a table; the renowned poet Countee Cullen may be one of the sitters. Something has

happened to divert them from their game, something that would appear, as indicated by their turned heads, to be happening at both sides of the room. Behind them, two men shoot pool.

While the faces of the men in the background are undefined, those of the cardplayers are depicted in more detail, with highly exaggerated facial features. Those in the forefront of the Harlem Renaissance loudly criticized this irreverent treatment, accusing Hayden of perpetuating stereotypical images of African Americans commonly found in popular culture. The artist retorted that he intended for his genre scenes of ordinary people doing ordinary things simply to be entertaining.

Viewers are invited to participate in the scene. Indeed, we can even peer over the central figure's shoulder and see his hand. Hayden spent many long evenings in Paris playing cards with his American friends. He celebrates this camaraderie in the watercolor, whose title is inscribed on the back of the chair.

Albert A. Smith

1896–1940

37. *Les Danseurs*

1930
Lithograph
Sheet: 9⅞ x 13 in. (25.1 x 33 cm)
Image: 7⅝ x 10½ in. (19.4 x 26.7 cm)
Gift of Reba and Dave Williams, 1999
1999.529.144

This troubling print depicts two elderly black men providing musical accompaniment for dancing black children on a boat dock. With its caricatured portrayal of an unkempt girl, a bedraggled boy, and two carefree older men, *Les Danseurs* is reminiscent of the popular genre scenes of nineteenth-century American culture that portray African Americans as content, carefree, irresponsible, and uneducable; frolicking, fun-loving minstrels are typically the subject matter of these pictures. Prior to the Civil War, racist caricatures often served to justify slavery by portraying African Americans as subhuman, fit only for servitude. After the war, such images

often romanticized the system of slavery in the United States, evoking a fanciful nostalgia for the "lost" slaveholding South.

Albert A. Smith's large body of work includes paintings, drawings, and prints that focus on a variety of subjects: ancient African civilizations, European landmarks, portraits, and genre scenes of the rural South. As a result of his clever marketing schemes—targeted at diverse, often conflicting audiences—Smith's work was widely exhibited. His images of Ethiopia, for example, appeared in magazines devoted to African-American uplift, such as *The Crisis* and *Opportunity*, while his 1930 series of stereotypical representations of African-American performers, which includes *Les Danseurs*, was probably intended for a French-speaking European audience, as suggested by the title. It should be noted that Smith lived in France from 1920 to 1940. As one of about a dozen large-edition prints depicting black musicians and dancers, Smith's disturbing series indicates that there was a viable market for such work across the Atlantic, as well as in the United States. (See also cat. no. 7.)

Louise E. Jefferson
1908–2002

38. *Nightclub Singer*
ca. 1938
Lithograph
Sheet: 11 x 14⅜ in. (27.9 x 36.5 cm)
Image: 8¼ x 11⅜ in. (21 x 28.9 cm)
Gift of Reba and Dave Williams, 1999
1999.529.68

Born as a genre of improvisational secular song among African Americans of the rural South, the blues migrated to the urban North with its artistic creators and their struggling audiences during the first half of the twentieth century. In its ability to articulate the joys and hardships of everyday life with courage, honesty, and passion, the genre has been central to African-American expressive culture.

In 1920, Mamie Smith recorded her own rendition of "Crazy Blues" and the recording sold seventy-five thousand copies within the first month of its release.[1] The song's runaway success opened the door for other black women blues singers, including Ida Cox, Alberta Hunter, Sippie Wallace, and Clara Smith. During the 1920s—the peak of the classic blues era—hundreds of African-American women had

their first opportunity to sing in clubs and record their work. Perhaps the most famous, Bessie Smith (1894–1937), known as the Empress of the Blues, was highly sought after as a performer and recording artist because of her incredible voice, suggestive lyrics, fierce independence, and sensuous glamour.

An instructor at the Harlem Community Art Center, Louise E. Jefferson assisted Riva Helfond in teaching students lithography, the medium of this Harlem nightclub scene. Jefferson was also a photographer, and her subjects often included famous musicians of the day.

With her commanding presence, dazzling looks, and mesmerized audience, the performer in this naturalistic print resembles many of the popular singers of the era who delighted their audiences with their compelling voices and heartfelt lyrics. Accompanied by one man playing an upright piano and another on a guitar, the singer provides a compositional transition between the energetic musicians in the background and the avid listeners in the foreground. As the word "Stormy" appears on the pianist's sheet music, it is possible that the singer is Ethel Waters (1896–1977) performing her own rendition of "Stormy Weather." Although the blues is considered a secular genre, it frequently overlaps with more sacred idioms. Fittingly, the singer in this spirited room is warmly encircled by a halo of light.

1. Angela Davis, *Blues Legacies and Black Feminism: Gertrude "Ma" Rainey, Bessie Smith, and Billie Holiday* (New York: Vintage, 1998), p. xii.

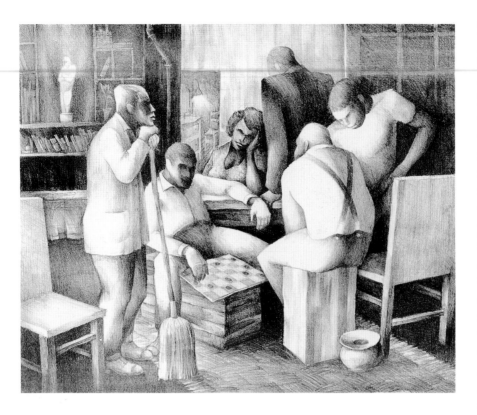

Robert Blackburn

born 1920

39. *Clubroom*

ca. 1937–39
Lithograph
Sheet: 15½ x 20½ in. (39.4 x 52.1 cm)
Image: 13⅛ x 16⅝ in. (33.3 x 42.2. cm)
Gift of Reba and Dave Williams, 1999
1999.529.8

Robert Blackburn is both a product and a model of inspired teaching. *Clubroom* was made soon after Riva Helfond introduced the teenage Blackburn to lithography. Helfond, a young artist herself, generously shared with her even younger apprentice her passion for the traditional materials of lithography. Reflecting on the importance of her teaching, Blackburn would later say, "I fell in love with printmaking because of Riva. She taught us the sensuality of stone."[1]

The Harlem Community Art Center gave Blackburn access to dedicated teachers and engaged peers. Romare Bearden, Jacob Lawrence, Norman Wilfred Lewis , Ernest Crichlow, and Charles Henry Alston (all artists represented in this catalogue) were all at the center during the period he was there. The center's devotees also helped the emerging artist to regard himself as a professional. This was an important vision for a teenager who knew that prejudice and discrimination stymied many career opportunities. Commenting on his childhood, Blackburn remarked, "When I grew up in Harlem, where there was not at that time any opportunity to do anything with anything you did, you didn't rate."[2]

Once owned by Helfond, *Clubroom*, which shows six people relaxing together around a checkerboard, possibly depicts the pivotal Harlem Community Art Center, or Alston's studio, 306, as paintings and sculptures appear in the room.

In 1948, at age twenty-eight, Blackburn opened the Printmaking Workshop in New York City. Drawing on his experiences with spirited teachers and vibrant community art centers, Blackburn established a studio where anyone could walk in and make prints. Now over fifty years old, the Printmaking Workshop is internationally acclaimed for its vitality and diversity— and for its master printmaker. Still captivated by seeing printmakers experience their prints, Blackburn explains: "The physical act of printing, of wiping the plate, of seeing the image come alive and seeing them explore [is a] very magical and mystical thing for me."[3] (See also cat. no. 26.)

1. Quoted in Dulcie Leimbach, "A Master and His Mecca on West 24th Street," *New York Times*, February 8, 1998, p. 32.
2. "Bob Blackburn Interviewed by Robert Berlind," *Art Journal* 53, no. 1 (spring 1994), p. 26.
3. Ibid.

Joseph Delaney

1904–1992

40. *Circle in the Square*

ca. 1940
Oil on masonite
36 x 24⅛ in. (91.4 x 61.3 cm)
Arthur Hoppock Hearn Fund, 1992
1992.350

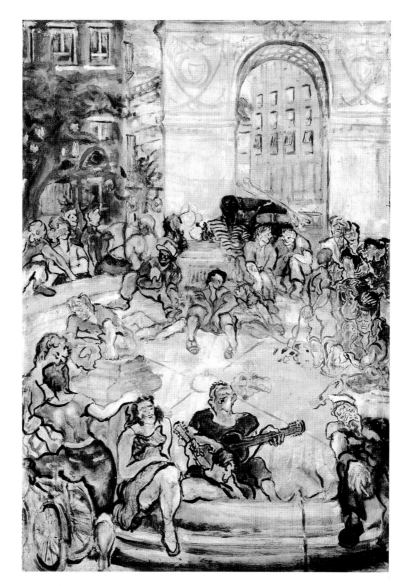

Exuberant crowds in public spaces is a recurrent theme in Joseph Delaney's joyful, expressionistic work, and lower Manhattan is frequently the site for his lively scenes. Born in Tennessee, Delaney arrived in his chosen city, via Chicago, in 1930 to meet up with his older brother, the painter Beauford Delaney (1901–1979), and to enroll at the Art Students League. While a student at the dynamic art school, from 1930 to 1932, he studied with Thomas Hart Benton (see fig. 1 on p. 13) and was strongly influenced by the painter's call for art confidently based on the American scene.

Paintings of parades and other public gatherings are central to Delaney's oeuvre, and for the next fifty years he depicted the pulsating life of the city. An active participant in the New York scene, Delaney both displayed his art and worked as a portraitist at the semiannual "Washington Square Outdoor Art Exhibit," from its inception in 1931 until the early 1970s. He described his fondness for these sidewalk shows:

> I want to talk about the dream of sitting on Sullivan Street looking over the green grass in the park watching people relaxing and enjoying the spark of nature they find under the trees feeding the pigeons and walking the dog and amusing the children. Old people enjoy the sunshine. Weary travellers and whoever so please just passing by and making a comment on something you have dared to bring out and show to the public. Showing on the curb is a way of life.[1]

Circle in the Square shows an eclectic mix of Greenwich Village revelers—musicians, bicyclists, servicemen, friends—relaxing on a summer's day in Washington Square Park.

1. Joseph Delaney, "39 Years Exhibiting in the Washington Square Outdoor Art Exhibit," *Washington Square Outdoor Art Exhibit* 78 (September 1970), pp. 37–39.

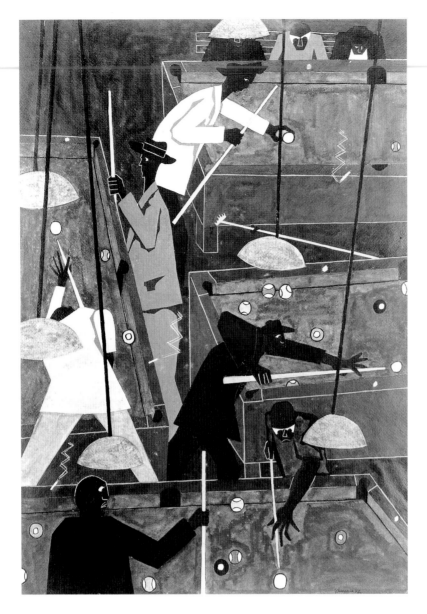

Jacob Lawrence

1917–2000

41. *Pool Parlor*

1942
Watercolor and gouache on paper
31⅛ x 22⅞ in. (79.1 x 58.1 cm)
Arthur Hoppock Hearn Fund, 1942
42.167

Jacob Lawrence was inspired by the geometry of outdoor city life; apartment buildings, windows, wheels, stoop steps, fire-escape ladders, and top hats are all recurrent in his work. Concerning his urban inspiration, he would later explain, "I grew up in New York City. I guess when you grow up in any city you become familiar with doorways and windows and looking through windows. I like the architectonic, geometric shapes of these things. I use these forms over and over again."[1] In *Pool Parlor*, the inventive modern painter took his affinity for the geometric lines and shapes of street life indoors. This interior scene of men at play largely consists of the sharp lines and angular shapes of urban living.

Strong lines, geometric shapes, flat forms, and bold colors are all characteristic of Jacob Lawrence's innovative style. This modern visual vocabulary, he believed, would help viewers of all backgrounds connect with his work: "For me a painting should have three things: universality, clarity, and strength. Universality so that it may be understood by all men. Clarity and strength so that it may be aesthetically good."[2]

Pool Parlor won a five-hundred dollar purchase prize at "Artists for Victory," an exhibition held at The Metropolitan Museum of Art in 1942–43 (see fig. 4 on p. 17). Perhaps viewers found respite from the anguish of the war in this painting of men at leisure, seemingly oblivious to the events of the outside world. (See also cat. nos. 18, 30.)

1. Quoted in Patricia Hills and Peter T. Nesbett, *Jacob Lawrence: Thirty Years of Prints (1963–1993): A Catalogue Raisonné* (exh. cat., Seattle: Francine Seders Gallery in association with the University of Washington Press, 1994), p. 31.
2. Quoted in Ellen Harkins Wheat, *Jacob Lawrence: American Painter* (Seattle: Seattle Art Museum, 1986), p. 192.

8. War

Despite the persistence of racial segregation within the armed forces during World War II, African Americans were actively involved in the war effort as military personnel and defense industry workers, as well as bond buyers and volunteers. Of the all-black units in operation, one of the most celebrated in the war was the Tuskegee Airmen, the first black flying unit to be trained by the Army Air Corps. It was not until 1948, three years after the end of the war, that integration of the military was mandated by President Harry S. Truman, in Executive Order No. 9981.

During the early 1940s, artists took up the subject of war in their posters, prints, and paintings, the majority of which were executed for the WPA art projects. The Fine Print Workshop of Philadelphia was asked specifically by the federal government to create mass-produced posters and fine art prints that supported the war effort, but elsewhere, too, the subject of war was widely explored by American artists. The imagery of the prints ranges from recorded observations about wartime life (cat. no. 46) to political commentaries about injustices perpetrated at home and abroad (cat. no. 45). But unlike the official artists and photographers who were at the front documenting actual battles and fatalities, most of the pictures made by artists at home express the patriotism and commitment of everyday citizens. They describe the daily routines of defense workers (cat. nos. 43, 44a, 46) and soldiers saying good-bye to their families (cat. no. 42) or jubilantly returning home (cat. no. 47).

For African Americans, however, this commitment to the government's actions abroad was tempered by the knowledge that their own fight against segregation and inequality, in both the workplace and the military, was still being waged at home. The popular phrase "double victory" suggested that African Americans were fighting a war on two fronts and that victory gained abroad would result in social and economic advancements at home. Such hopeful sentiments were not immediately realized, but they paved the way for tangible gains in the decades that followed.

LMM

William Henry Johnson

1901–1970

42. *Off to War*

ca. 1942
Screenprint
13¾ x 17⅞ in. (34.9 x 45.4 cm)
Gift of Reba and Dave Williams, 1999
1999.529.80

Many African Americans joined the armed forces in the belief that heroic participation in the war effort would enable their goal of full citizenship at home. Yet when war erupted in Europe in 1939, the armed forces in the United States were racially segregated and the few all-black regiments lacked resources, training, and power. Recognizing that valiant service in wartime could translate into political power in peacetime, the formidable civil rights leader A. Philip Randolph (1889–1979) pressed President Franklin D. Roosevelt in 1940 to provide more training and opportunities for black servicemen, and he urged all African Americans to "demand the right to work and fight for our country." Successful wartime efforts, Randolph insisted, would enhance civilian life.

On the eve of World War II, William Henry Johnson, who had been living as an expatriate, returned to the United States after a decade of artistic exploration abroad. Although he had largely painted landscapes in Europe, when he resettled in New York City he focused his work on everyday African-American life. Johnson also developed a deliberately naive style informed by American folk art and traditional African sculpture.

Made shortly after the United States officially entered the war, *Off to War* shows a young black soldier waving good-bye to his patriotic family as they stand outside their humble home. Using a printmaking technique that produces an effect that resembles tempera and gouache painting, the screenprint is similar in look and style to the wartime pictures of Jacob Lawrence (see cat. nos. 18, 30, 41). With its bright colors, simplified forms, and stylized figures, the print draws on the vocabulary of European modernism to narrate a truly American story. In this visual tale, an African-American recruit leaves his rural home to pursue a "double victory," seeking victory against tyranny abroad and victory against racial discrimination at home. (See also cat. no. 2.)

Dox Thrash
1893–1965

43. *The Welder*
ca. 1936–41
Carborundum mezzotint
Sheet: 10 x 6 in. (25.4 x 15.2 cm)
Plate: 4⅞ x 4 in. (12.4 x 10.2 cm)
Gift of Reba and Dave Williams, 1999
1999.529.167

African Americans, particularly those living in industrial areas, grasped the new opportunity to work on the home front (see cat. nos. 44a, b, 46), and between 1942 and 1944 the percentage of African Americans in defense work increased from 3 percent to more than 8 percent.[1]

Dox Thrash's *The Welder* portrays one of the million African Americans who found wartime employment. Fully outfitted in the protective helmet, big gloves, sturdy shoes, and flame-resistant uniform that make up a welder's gear, this broad, anonymous figure serves as a powerful symbol of the home-front war effort. Although the print is extremely small, its size does not diminish the monumentality of the figure. Surrounded by darkness and illuminated by the flames of his blowtorch, the welder meets the needs of his country as he performs the blistering job at hand.

Made at the Fine Print Workshop of Philadelphia, this carborundum mezzotint (see pp. 87–88) was made in response to the government's call for artists to produce work that addressed wartime life. (See also cat. nos. 16, 28.)

1. Bernard C. Nalty, "World War II," in *Encyclopedia of African-American Culture and History*, ed. Jack Salzman, David L. Smith, and Cornel West (New York: Simon and Schuster, 1996), vol. 5, p. 2885.

Calvin Burnett
born 1921

44a. Navy Yard, no. 6, *Grinder*
1942
Linocut
Sheet: 10⅛ x 8 in. (25.7 x 20.3 cm)
Image: 9⅛ x 7 in. (23.2 x 17.8 cm)
Gift of Reba and Dave Williams, 1999
1999.529.19

44b. War Workers, no. 7, *Going In*
1943
Linocut
Sheet: 10⅛ x 7¾ in. (25.7 x 19.7 cm)
Image: 9 x 7 in. (22.9 x 17.8 cm)
Gift of Reba and Dave Williams, 1999
1999.529.23

Directly after graduating from the Massachusetts School of Art in Boston in 1942, Calvin Burnett joined the home-front workforce. Employed as a laborer at the Boston Navy Yard, he repaired and cleaned military ships at the busy dry dock until the war's end. During the war, the Boston Navy Yard employed nearly fifty thousand people, and work continued around the clock, seven days a week. While there, Burnett made a series of sketches from memory, titled Navy Yard/War Workers, based on everyday wartime life. *Grinder*, a print based on one of these sketches, depicts a man on a scaffold grinding rust off the hull of a ship. Based on the artist's own experiences, the image reflects the monotony of his routine and his sense of anonymity:

> In the spring of 1942, my father died, I was drafted, graduated from art school and went to work as a laborer in the Boston Navy Yard. I remember these as the miserable war years until 1945 when I was laid off. I usually worked seven days a week, alternating between the three different shifts, with time-clock punching, unreliable commuting, difficult working conditions, too hot, too heavy, too cold, outdoors in all weather and in huge and cramped broken tanks and bilges.[1]

In contrast to *Grinder*, Burnett's *Going In*, also part of the series, portrays a group of men and women in lively conversation "going in" to work. Both prints are linocuts, a medium that lends itself well to linear design. Here, the expressive, sketch-like quality serves to accentuate the strong bodies and animated poses of the wartime commuters as they enjoy one another's company before the start of their workday. (See also cat. no. 22.)

1. Quoted in Dewey F. Mosby, ed., *Life Impressions: 20th-Century African American Prints from The Metropolitan Museum of Art* (exh. cat., Hamilton, N.Y.: Picker Art Gallery, Colgate University, 2001), p. 37.

John Woodrow Wilson

born 1922

45. *Deliver Us from Evil*

1943
Lithograph
Sheet: 15¼ x 19⅜ in. (38.7 x 49.2 cm)
Image: 12⅛ x 15⅛ in. (30.8 x 38.4 cm)
Gift of Reba and Dave Williams, 1999
1999.529.191

Inspired by the socially engaged work of the modern Mexican muralists, Boston-born John Woodrow Wilson created this graphic commentary on World War II. The title of the print derives from an assignment Wilson was given while a student at the School of the Museum of Fine Arts, Boston, to interpret the phrase "deliver us from evil." Similar to a mural in its intricate composition, dramatic scenes, and epic scope, *Deliver Us from Evil* is a bold meditation on injustice.

Deemed physically unfit for military service, Wilson experienced the war from Boston, and his feelings about it were mixed. On the one hand, he strongly supported the military effort to stop the spread of fascism and anti-Semitism and to liberate people from oppression, racial supremacy, and genocide. On the other hand, he saw many Americans fighting for freedom in Europe while denying it to African Americans at home. It is this paradox that gives the image its power.

Conceived as a vehicle to expose the contradiction between international concerns and domestic realities, the print consists of mirror-image scenes that contrast the horrors of hatred in Europe with the injustices faced by African Americans in the States. On the left, concentration camps, Nazi soldiers, and the bodies of victims surround a Jewish family. On the right, decrepit tenement buildings, a lynch mob and its victim, and rich industrialists enjoying the benefits of labor disputes encircle an African-American family, whose father figure may be a self-portrait of the artist. Through these graphic juxtapositions, *Deliver Us from Evil* exposes the destructiveness of apathy, hatred, and greed both at home and abroad. (See also cat. no. 46.)

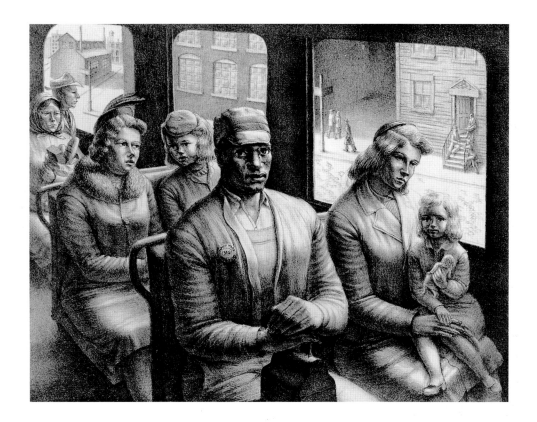

John Woodrow Wilson

born 1922

46. *Elevated Streetcar Scene*

1945
Lithograph
Sheet: 14⅛ x 17⅜ in. (35.9 x 44.1 cm)
Image: 11¼ x 14¾ in. (28.6 x 37.5 cm)
Gift of Reba and Dave Williams, 1999
1999.529.198

It was not until three years after the war's end, in 1948, that President Harry S. Truman signed an executive order providing for the integration of the armed forces. But while segregation defined wartime military service, integration guided defense work at home. In 1941, under the administration of President Franklin D. Roosevelt, racial discrimination in hiring was banned in defense industries and training programs were opened up to minorities.

Fatalities at the front, stepped-up military action, and increased production to meet the needs of the war machine had created a national labor shortage, and citizens not previously considered for factory jobs and shipyard labor were employed to fill the gap.

Reflecting on the changing face of labor in wartime Boston, John Woodrow Wilson recalled:

> I wanted to see Hitler defeated like everyone else, but I resented the fact that almost everyone on my block was on welfare until they needed us in the shipyards and factories. And I resented the idea of blacks going off to fight for other people's freedoms while ours were being neglected at home.[1]

Elevated Streetcar Scene chronicles this moment of social transformation. An African-American man, dressed in a workman's coveralls, wearing a cap, and carrying a metal lunchbox, commutes to work on an elevated streetcar, his Boston Navy Yard identification badge in plain view. Seated around the black commuter are six white passengers, most of them women, who chat or are preoccupied, lost in thought. But the man directly meets our gaze, inviting us to ponder the burdens and responsibilities of his wartime life. (See also cat. no. 45.)

1. Quoted in Amy Tarr, "A Capital Career," *Boston Phoenix*, March 12, 1993.

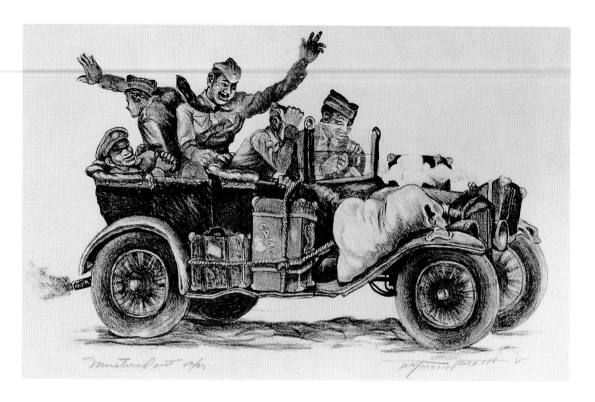

Raymond Steth

1917–1997

47. *Mustered Out*

ca. 1945
Lithograph
Sheet: 8⅞ x 11⅞ in. (22.5 x 30.2 cm)
Image: 6⅝ x 10⅝ in. (16.8 x 27 cm)
Gift of Reba and Dave Williams, 1999
1999.529.156

Racial segregation permeated the United States military when World War II erupted in Europe in 1939. Yet from the war's outset, African Americans constantly struggled for better treatment and greater opportunities within the armed forces. Often believing that discriminatory military policies were based on entrenched beliefs that African Americans lacked intelligence, courage, and skill, black men and women worked to shatter these damaging myths by demonstrating their knowledge and bravery and consistently performing at high levels. While serving within the confines of the segregated forces, they also worked to eradicate racism and to ban all forms of discrimination in the military, including the strictly enforced principle of "separate but equal." Many African Americans understood this activist work as part of the "double victory" campaign. They believed that a victory against tyranny abroad would enable a victory against racial discrimination at home.

Made after Raymond Steth had completed the epic wartime panorama *Beacons of Defense* (see fig. 9 on p. 88), his merry *Mustered Out* reveals the joy of the Allied victory and hints at the high expectations for postwar America. Recently discharged from service, this happy group of black soldiers in their loaded-up jalopy are fully enjoying their victorious ride home. One man's trunk, with its drawing of two intertwined hearts, hints at life's romantic possibilities. New social and political developments, however, are still unforeseen because the jubilant men do not yet realize that the wartime activists and their valiant efforts to achieve freedom and equality will soon activate the Civil Rights movement. Within a decade, they will see that victory abroad has inspired African Americans to courageously challenge American society to live up to its professed democratic ideals. (See also cat. nos. 17, 27.)

Printmaking Techniques of the WPA Printmakers

RACHEL MUSTALISH

Prints are made when designs are created on one material and then, by a series of processes, transferred to a final support. Because it is possible to produce multiple copies of the same image, the medium has enabled a broad public to have access to images and has been used as an instrument for the dissemination of information and ideas. The print medium has been explored by artists for centuries as a means of creating effects that could not otherwise be achieved, and the technical possibilities of printmaking are many and diverse, offering the artist a wide range of expression.

Technical and artistic developments both influence and mirror the trends of the day. The prints of the first half of the twentieth century were made in an environment of technical advances, a renewed sense of the place of the artist in American culture, the Great Depression, and the subsequent support of the federal government through various programs of President Franklin D. Roosevelt's New Deal.

Printmaking in the United States developed quickly in the nineteenth century as a result of the rapid growth of industrialization. The centers of activity were the big cities—New York, Chicago, Philadelphia, and Boston—where prints were employed primarily as a means of reaching a large population through advertising, illustrated newspapers and periodicals, and art that was purchased through mail order. The wide distribution of the printed image, long considered a democratic medium, gave impetus to "American art for Americans," a movement that gained momentum during the WPA era.[1]

Of the few nineteenth-century African-American printers whose names have survived, Scipio Moorehead (active ca. 1773), Patrick Reason (1817–ca. 1850), and Grafton Tyler Brown (ca. 1841–1918) are the most well known;[2] most of the skilled black laborers in the printing industry, however, remain unidentified. In the early twentieth century, large urban centers of the North began to foster African-American activity in the arts. Agencies such as the Harmon[3] and Rosenwald[4] Foundations awarded grants to African-American artists for study and travel, and federal grants for education also became available to veterans of World War I. In New York City, during the artistic flowering of the Harlem Renaissance, literary publications, journals, and magazines created a demand for graphic arts by African Americans to be used as illustrations.

The Great Depression ended much of the patronage for artists. Roosevelt understood that providing government-sponsored employment was a way to preserve the country. Federal and state programs that sponsored artists began in 1933, and soon after, in 1935, the larger encompassing agency, the Works Progress (later Work Projects) Administration/Federal Art Project (WPA/FAP) was established.

The large urban cities of the North had been centers of printmaking in the nineteenth century; therefore, it is not surprising that these locales also became centers for graphic art activity during the WPA era. Many of these places, such as the Playhouse Settlement/Karamu House in Cleveland and the Harlem Community Art Center in New York City, were established centers of the African-American arts community even before they received federal funding and became WPA workshops. To

Figure 5. Detail from *The Lamppost*, by William E. Smith (cat. no. 20), showing the pools of ink along the edges of forms produced by relief printing.

their benefit, these centers were already set up to function as schools and had a tradition of teaching and apprenticeship. Many of the printmakers and painters in this exhibition who became important leaders, teachers, and artists in the WPA workshops were already established and highly knowledgeable and had been taking advantage of the thriving art communities in the United States, Europe, and Mexico.

The result was an increased production of graphic art and a renewed public interest in prints, and in American subject matter and technology. The WPA programs also provided artists with resources and with time to create. They gave African-American artists more opportunities to work as professionals and to exhibit in a greater variety of venues than ever before. These artist had proper jobs and thus were afforded relief from the oppressive economic climate of the Depression. They were given inks, paper, and presses and a community of talented people that fostered creative freedom and experimentation.

It was only because printmaking was already an established part of the art scene before the Depression that it gained a prominent place in the government's public art programs. The work of the WPA artists was promoted by exhibition and journals and through print clubs and organizations that continued to flourish across the United States long after the government programs ended.

Most forms of printmaking require training and skill, and the results are highly dependent upon knowledge of various techniques. Printmaking techniques can be divided into three main types: relief, intaglio, and planographic. Because of the physical properties inherent in the materials used for each method, there are certain characteristics that can be exploited for artistic effect. Several of the printmaking methods used by the WPA artists are described below.

RELIEF PRINTING

In relief printing, a design is carved from a flat block of material, and the area to be printed is left in relief. Woodcut, wood engraving, and linoleum cut all are types of relief printing, each of which uses a different material from which to carve the design.

Woodcuts are made by using various types of knives to cut away the wood from the block, leaving in relief the area that will receive the printing ink. The ink is transferred to a sheet of paper by pressing the paper to the inked wood block by hand or with a press. The woodcut is often thought to be the oldest form of printing.[5] It gained popularity for book and newspaper illustration because it could be printed simultaneously with typeface, thereby increasing the speed and decreasing the effort needed to print illustrated material. The process lends itself to a highly linear graphic design, and the patterns of the wood grain are often visible in the final print. The pressure applied during printing can also emboss the paper, enhancing the textural quality of the print. (See cat. nos. 4, 9, 13.)

Wood engraving, a variation of the woodcut, uses a harder type of end-grain wood. The hardness of the wood makes it possible to achieve very sharp, crisp lines, an effect that lends itself to the depiction of night scenes and dark interiors by

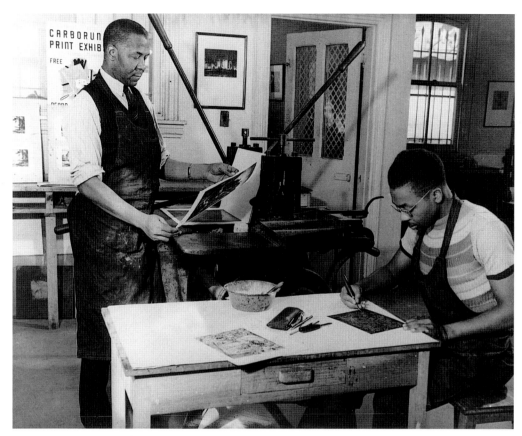

Figure 6. Dox Thrash, left, and Claude Clark at the Fine Print Workshop of Philadelphia, ca. 1940. There is a printing press in the background, and Claude Clark is shown using a burnisher on a metal plate for an intaglio print. Photo: Myron Krasney

creating white highlights that mimic light effects. *Still Life with Fetish* (cat. no. 3) and *Harangue* (cat. no. 23), both by Wilmer Angier Jennings, show the characteristic white lines and create scenes that capture the intricate play of light in a dark setting.

The linoleum cut, or linocut, is another type of relief print. Linoleum is a material made from cork, linseed oil, and other resins and gums molded flat onto canvas or burlap. Originally manufactured in the mid-nineteenth century to be used as flooring,[6] it became an attractive material for printmakers because it was cheap, readily available, and softer than wood and therefore easier to cut. Like woodcut, linocut lends itself to linear graphic designs, but because it is softer, it can more easily produce

curved lines; it became one of the most popular techniques employed by the WPA printers.

Calvin Burnett's Navy Yard, no. 6, *Grinder*, and War Workers, no. 7, *Going In* (cat. nos. 44a, b), have wiggly, nervous lines that vary in density. The pools of ink at the edges of the lines are characteristic of linocut, and of relief printing in general. *Tavern* (cat. no. 22), also by Burnett, shows the grain pattern that can be achieved with linocut, and William E. Smith's *The Lamppost* (cat. no. 20) exemplifies a linocut where the ink is laid on the paper as a solid, glossy surface. The pooled ink in this print is so well controlled that it becomes a subtle accent of the design itself (fig. 5). The linocuts *African-American Madonna* and *Jesus Is Nailed to the Cross*, by Allan Rohan Crite

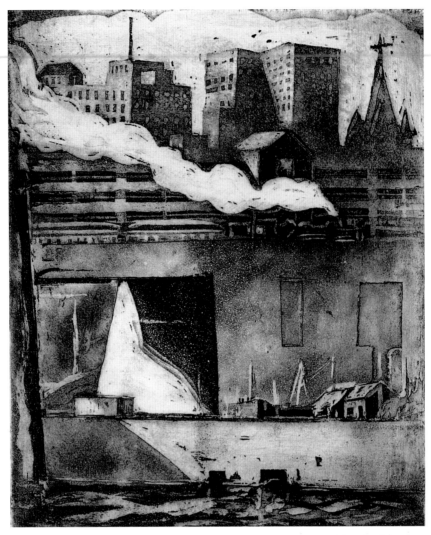

Figure 7. Dox Thrash (1893–1965), *Cityscape*, ca. 1940. Aquatint. Sheet: 8? x 6? in.
(20.6 x 17.5 cm). Plate: 5 x 4 in. (12.7 x 10.2 cm). The Metropolitan Museum of Art, Gift
of Reba and Dave Williams, 1999 (1999.529.168)

(cat. nos. 25a, b), are relief prints in which the lines of the block are so firmly pressed into the crisp, thin paper that the surface is given a topographic effect.

INTAGLIO PRINTMAKING

In the intaglio process, the area that is to be printed is removed from a sheet of metal, called a plate. Copper is the traditional material used for the plate because it is soft, but other metals, such as zinc and steel, can also be used. After the metal is removed in the area of the design, the plate is covered with ink. The surface of the plate is then wiped clean, leaving ink only in the recessed areas. The ink is transferred to the paper by the pressure of the printing press, which pushes the paper into the recesses, transferring the ink to the paper. For this reason, the inked areas on intaglio prints can be raised (see fig. 6 on p. 85).

Various methods are employed to remove the metal from the plate. In engraving, a tool called a burin is used to gouge out the metal. In dry-

point (see cat. no. 16), the plate is scratched with a needle. This method creates fine, sharp lines and a metal burr that can catch the printing ink, giving a dense, rich appearance to the printed line. In both instances, the hand of the artist is revealed in the printed image.

Etching is a method in which acid is used to remove metal from the plate. To make an etching, a thin layer of resin, which protects the metal from being etched by the acid, is applied to the plate. To create the design, various tools—knives, needles, styli—are used to disturb the resin layer, thereby allowing acid to reach the metal in these areas. Because in this method the design is made in the resin rather than in the metal itself, it is possible to create design elements that are freer and more curvilinear. See, for example, *Wrecking Crew*, by Charles L. Sallée Jr. (cat. no. 34).

The rendering of tonal variation in metal-plate printing has been a challenge to artists for centuries. To achieve tonal effects a roughened surface, called a grain, must be applied to the plate. Many methods have been developed to create these effects. In mezzotint, invented in the seventeenth century, a rocker tool with metal teeth (called a mezzotint rocker) is used to abrade the metal plate, causing an overall texture that can receive the printing ink. The design is made by smoothing out the grain with a burnisher, creating light areas from the darks. In aquatint, developed in the eighteenth century, grains of resin are put on a plate, either as dust or in a liquid solution. The resin adheres to the plate, which is then placed in an acid bath. The resin droplets resist etching, causing a roughened, grained surface. Because aquatint grains can be of various sizes and applied in liquid form, manipulation of the aquatint material can produce a variety of tones that mimic watercolor or ink wash. This effect can be seen in *Cityscape*, by Dox Thrash (fig. 7).

Thrash was a remarkable printmaker. He joined the WPA's Fine Print Workshop of Philadelphia in 1937. Thrash invented a

Figure 8. Detail from *The Welder*, by Dox Thrash (cat. no. 43), showing the white highlights and subtle gray tones that result from burnishing on the printing plate in the mezzotint process. The texture of the printing plate caused by the grained metal plate can also been seen.

process known as carborundum printing.[7] He was later joined in its development by two other WPA artists also in Philadelphia, Hugh Mesibov (b. 1916) and Michael J. Gallagher (1898–1965). The technique offered a new way to achieve tonal variations and was heralded as a major innovation: "People are coming from all over town to see the new exhibition of 'carborundum prints,' but after looking them over, they invariably want to meet the three inventors of the carborundum process—the first important innovation in the print maker's art in a century."[8]

Carborundum is the commercial name for a very hard synthetic abrasive made by fusing coke and sand and used for grinding and polishing.[9] Thrash and other printmakers would have been familiar with this material, as it was used to prepare lithographic stones. In carborundum printing, the gritty material is used to roughen the surface of the metal printing plate. This surface, as with mezzotint and aquatint, has sufficient divots in the plate to hold ink and to print as a rich black field. The design can be made in two ways. One, in the manner of mezzotint (the process is sometimes called carborundum mezzotint), is to burnish and smooth

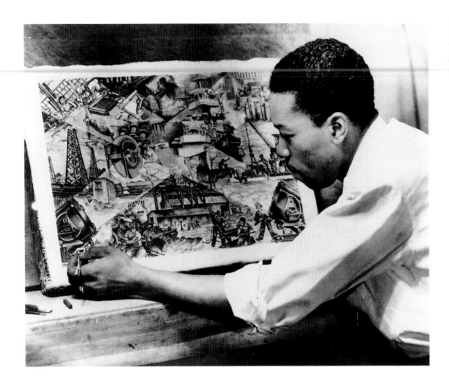

Figure 9. Raymond Steth working on a lithographic stone for the print *Beacons of Defense*, 1941. Photo: Charles Ricker

the roughened surface. This makes it possible to work in midtones and highlights, as the burnished areas do not hold as much ink as the roughened areas. Other effects can be produced by selective wiping of the plate before printing. The result is a smoky, atmospheric effect that achieves a great variety of subtle tones. The second type of carborundum printing is called carborundum etching. In this process, additional etched lines are created and the plate is then inked and printed as a relief plate.

Thrash's *The Welder* (cat. no. 43)—in which the sparks that emerge from the darkness serve to highlight the figure of the worker—is a beautiful example of carborundum mezzotint (fig. 8). The ridged paper on which the image is printed also lends texture to the surface. *Glory Be* (cat. no. 28), also by Dox Thrash, combines carborundum with aquatint and etching. The carborundum provides the grainy, hazy atmosphere; the aquatint gives the figures in shadow a dark yet textured form; and the etching produces the strong black outlines that accentuate

the forms. Although several artists experimented with this technique and it was heavily promoted by the WPA to show the inventiveness and ingenuity of its artists, its primary growth was through Thrash and other WPA artists from Philadelphia. In Philadelphia, intaglio was one of the dominant techniques used, although this was not the case at other WPA locations.

SCREENPRINTING

Screenprinting—also known as silk-screen printing and serigraphy—was invented in the early twentieth century for commercial use in packaging and advertising. The technique is highly effective in creating high-tone, multi-color prints, and it was quickly adopted by artists. It is also a low-cost method and does not require a press. In screenprinting, a stencil is first applied to a fabric screen. Ink or paint is then pushed through the screen onto a paper support with a flat, rubber-edged tool called a squeegee. The stencil prevents the ink from

passing through the mesh screen in selected areas, thereby creating the design. The stencil can be made by applying cut paper or fabric to the screen or by painting directly onto the screen with glue or shellac that will harden and act as a barrier to the ink. By 1935, the WPA Poster Division in New York City used this method to make posters. In 1938, the Silk Screen Unit of the Graphic Art Division was established by Anthony Velonis, who recognized the "highly valued effect of [screenprinting's] personal touch.[10]

William Henry Johnson, who joined the WPA in 1939, used the screenprint to produce bright, expressive works. In *Off to War* (cat. no. 42), he exploits the stencil features of screenprint to lay down planes of brilliant color. Screenprints from these years are often described as painterly because, with their rich pigment layer, they resemble gouache or tempera. These artistic screenprints reveal the drips, scrapes, puckers, and bubbles caused during the hand-printing process, and they often have the imprint of the screen mesh in the ink. The process was considered quite avant-garde during the WPA era and was touted as another example of American inventiveness.

LITHOGRAPHY

Lithography was one of the most popular printing methods among the WPA printmakers. It was invented in 1798 by the German printmaker Aloys Senefelder (1771–1834), who discovered that fine-grained Bavarian limestone could be drawn on and treated to accept and then transfer ink to a paper support.

The lithographic image is created by drawing on a stone with a greasy material called tusche or lithographic crayon (fig. 9). Printing ink is then applied to the stone. The ink adheres only to the areas covered with the tusche and is repelled by the blank areas. The ink is then transferred to paper by rolling both the stone and the paper through a press. After an edition is printed, the stone can be ground down (with

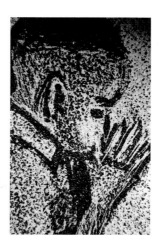

Figure 10. Detail from *Heaven on a Mule* by Raymond Steth (cat. no. 27). On the hands of the small boy, the crisp white highlights appear as scratch marks, an effect achieved in the lithographic process.

carborundum) and used again. Although the technique has been adapted to plates of zinc and aluminum, many artists continue to use the stone because it provides texture and softness to the final print.

Because tusche can take numerous forms—such as crayon, pencil, or liquid to be applied with a pen or brush—the resulting print can mimic a variety of drawing processes. Lithography, more than any other printing method, most directly reveals the hand of the artist in its capacity to reproduce strokes, brush, and pen marks. Designs can also be made on lithographic transfer paper, which allows the artist to work on paper rather than on a heavy stone, enabling him or her to work away from the printing studio.

The portrait *Robert Blackburn* (cat. no. 8), by Ronald Joseph, is an example of the drawinglike appearance that can be achieved with lithography. In this print, the strokes of the crayon are clearly visible, revealing the pressure of their application, and shading and contour are effectively rendered. Another feature of the lithographic process is the ability to produce crisp white lines. These are made by scratching into the stone itself. The cross-hatchings and highlights that can be made by such scratching are an essential element of Raymond Steth's *Heaven on a Mule* (cat. no. 27; fig. 10).

The power of artistic expression and the range of printing technology evident in these prints are nothing less than remarkable. A unique feature of this body of work is the combination of process and expressiveness. Printmaking processes are complex and require apparatus, materials, and technical knowledge, yet the prints produced by the artists in this exhibition never appear mechanized or removed from the maker. As dictated by the WPA, the prints were made in small editions.[11] The technical innovations made by the artists of this period are an important part of their legacy, and their contributions laid the ground for printmakers during the second half of the twentieth century. Americans gained confidence in the nation's printed work before other media because it is based on technology that Americans perfected. Holger Cahill, national director of the WPA/FAP, proclaimed: "American art is declaring a moratorium on its debt to Europe and returning to cultivate its own garden."[12]

The African-American artists included in this exhibition made significant contributions to the development of American art and printmaking, further establishing the print as a valid and vital form of artistic expression.

1. The notion of prints (and art in general) being democratic was strengthened in the second half of the nineteenth century; see Peter C. Marzio, *The Democratic Art: Pictures for a 19th-Century America; Chromolithography, 1840–1900* (Boston: D. R. Godine, 1979), p. 208. This belief was further advanced during the WPA era with the government-sponsored exhibition "Prints for the People," held in 1937 in New York. See "'Prints for the People' Reveal Work of WPA in Graphic Media," *Art Digest* 11 (January 1, 1937), p. 23.

2. Sharon F. Patton, *African-American Art* (Oxford: Oxford University Press, 1998), pp. 57, 81.

3. The Harmon Foundation was established in 1922 to provide grants to African-American artists.

4. Julius Rosenwald (1862–1932) was a philanthropist who contributed to schools, YMCAs, and other educational institutions for African Americans.

5. Relief prints from the seventh century A.D. have been found, but the process is probably considerably older.

6. Linoleum was a trademark for a resilient, washable floor covering. It was patented by Frederick Walton in 1863 and was common from the 1860s to the 1940s. Currently, the name linoleum is used for a variety of other sheet-type floor coverings, such as vinyl. See Gerhard Kaldewei, ed., *Linoleum: History, Design, Architecture, 1882–2000*, translated from German by Ingrid N. Bell (exh. cat., Ostfildern: Hatje Cantz, 2000), p. 244.

7. When the carborundum method was first developed, the prints were called carbographs. Thrash called them Opheliagraphs, after his mother, Ophelia.

Henri Goetz is given credit for the "new" technique of carborundum printing with his 1968 publication *Gravure au carborundum: Nouvelle technique de l'estampe en taille douce* (Paris: Maeght, 1968; 2nd ed., 1974); see *The Dictionary of Art*, ed. Jane Turner, (New York: Grove, 1996), vol. 5, pp. 725–26. In this process the carborundum grit is combined with glue, paste, or varnish and applied to a plastic or metal support. This surface is then inked and printed.

8. Joseph Shallit, "Gallagher, Mesibov and Thrash," in the *Philadelphia Record*, October 1, 1940; quoted in John W. Ittmann, ed., *Dox Thrash: An African American Master Printmaker Rediscovered* (exh. cat., Philadelphia: Philadelphia Museum of Art, 2001), p. 22.

9. In 1940 the WPA published a circular describing the carborundum process: *W.P.A. Technical Series; Art Circular*, no. 5, *The Carborundum Print* (Washington, D.C.: Federal Works Agency, Work Projects Administration, 1940). See also Cindy Medley-Buckner, "Carborundum Mezzotint and Carborundum Etching," *Print Quarterly* 16, no. 1 (1999), pp. 35–49, and Richard Hood, "Carborundum Tint: A New Print-maker's Process," *Magazine of Art* 31 (November 1938), pp. 643, 670–71.

10. The WPA issued technical information on the new screen-printing process similar to the carborundum circular (see note 9 above); see Anthony Velonis, *Technique of the Silk Screen Process*, 2 vols. Technical Problems of the Artist, [vol. 1] (New York: Work Projects Administration Program, [ca. 1939]), p. 1.

11. The editions were 25–75 according to Gustav von Groschwitz, director of the Graphic Arts Project of the WPA/FAP, see his article, "Making Prints for the U.S. Government," *Prints* 6 (February 1936), pp. 135–42.

12. Cahill, quoted in Ittmann, *Dox Thrash*, p. 23.

Photograph Credits

Figures 1, 2, 4, 5, 7, 8, 10, 11: The Metropolitan Museum of Art, New York

Figure 3: From *The African-American Mosaic: A Library of Congress Resource Guide for the Study of Black History and Culture* (Washington, D.C.: Library of Congress, 1993), p. 187.

Figures 6, 9: Federal Works Agency, Work Projects Administration, on deposit at the Philadelphia Museum of Art